By Hand

Running Press
Hachette Book Group
1290 Avenue of the Americas, New York, NY 10104
www.runningpress.com
@Running_Press

Printed in China

First Edition: April 2018

Published by Running Press, an imprint of Perseus Books, LLC, a subsidiary of Hachette Book Group, Inc. The Running Press name and logo is a trademark of the Hachette Book Group.

The Hachette Speakers Bureau provides a wide range of authors for speaking events. To find out more, go to www.hachettespeakersbureau.com or call (866) 376-6591.

The publisher is not responsible for websites (or their content) that are not owned by the publisher.

Photographs © 2017 by Sunny Y. Kim

Print book cover and interior design by Susan Van Horn.

Library of Congress Control Number: 2017958164

ISBN: 978-0-7624-6341-1 (paperback), 978-0-7624-6508-8 (ebook), 978-0-7624-6509-5 (ebook), 978-0-7624-6507-1 (ebook)

RRD-S

10 9 8 7 6 5 4 3 2 1

We are grateful to the many artists and makers who have allowed their work to be highlighted in this book. Permission to feature these pieces has been granted by: Uber Chic Home (cover, page 236); Photoflood Studio (page 9); Ashwood Avenue (page 35); Jordan/Dani (page 35); Wellen Women (page 35); Moglea (page 40); Robert Siegel (pages 40, 45); confectious (page 63); Tono + co (pages 161, 165); Hawkins New York (pages 193, 205); Lauren / Abby Ross for Bash Please (inside back cover).

Cheers

Love

Sophi

Britt + Brian Grant
622 Ashwood Avenue
Los Angeles, California
9 0 0
4

Party
Time!

WHO

WHAT

WHEN

WHERE

RSVP

Kelly Marla

By Hand

The Art of Modern Lettering

NICOLE MIYUKI SANTO

RUNNING PRESS
PHILADELPHIA

Patti
Thank you for the
support ♡ I hope you enjoy
this book!
♡, Nicole

Contents

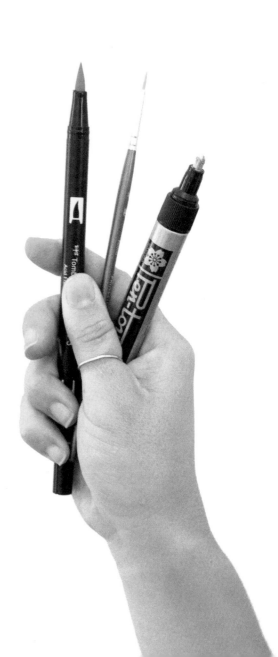

LESSONS / PROJECTS

The Movement of Lettering

In our world of screens and social media, people are searching for ways to reconnect to the hand-made and the authentic, to feel that spark of the personal in their interactions and in the objects that surround them. The art of modern lettering is a point of connection, a way of crafting the letters and words we use daily and turning them into something we feel in our soul.

Think of the moment you walked into a dinner party and saw your name written at your place setting, or when you received a hand-lettered envelope from your dear friends who are celebrating their special love, or the moment you set foot in a room with a quote on the wall and instantly felt at home. The sensation right there: *that* is something special.

This book is *your* invitation—an invitation to create the same warmth you remember and share it with your loved ones. This isn't about making something pretty or feeling like it needs to be perfect. It's about connecting to what is in your heart and soul and bringing it into the light. From making balloons for your next celebration to lettering on found objects like sea glass, rocks, and leaves, *By Hand* is filled with projects and lessons for you to experience, learn, and create while finding joy, gifting it to others, and making this world a little brighter one letter at a time.

What is Modern Lettering

The new wave of modern lettering isn't about being perfect or having all your letters written exactly on a straight line. Spoiler alert: There's no penmanship award for you to win, nor will you be asked to write with a quill and ink. Modern lettering is about *drawing* letters, not *writing* them. It is embracing the perfectly imperfect, the freedom to express yourself, and the liberty to experiment.

Maybe you've heard the terms *calligraphy*, *brush lettering*, *hand lettering*, or *fonts* and wondered what the difference is among them. To be honest, I wonder the same thing too. Typically, calligraphy is created with a pointed nib and brush lettering with a brush, while hand lettering with pens refers to stylized block letters. Then there are fonts used on the computer designed to print exactly the same every single time. To add to the options, there are now fonts for the computer that mimic calligraphy, brush lettering, and hand lettering, so it all blurs together. At the end of the day, each of these is a form of lettering, and one isn't any better than the other.

For purposes of this book, just remember that modern lettering is *not* your handwriting. It's the way lines form shapes and these shapes form words. It's the decisions you make as the creator to produce lines thin or thick, angled or straight—it is intentional. Modern lettering is redefining the way we look at letters, giving us the reminder to see and appreciate the beauty in making something *by hand*.

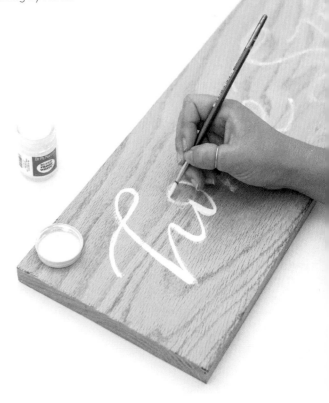

My Letter to You

This book made it into *your* hands for a reason. Maybe you've seen lettering on social media and want to try it out for yourself, or you're getting married and want to DIY everything for your special day. Maybe your friend bought this for you as a not so subtle hint that she wants her artist friend to do the lettering for her upcoming baby shower. Whatever the reason, and whether this is your first time lettering or your hundredth, this book is here to help.

There is no need to be classically trained or have any sort of art background. And although you may be thinking otherwise, you do not need to have nice handwriting. What you hold in your hands is not just a step-by-step guide; it's a book filled with knowledge that I hope to pass on to you, lettering lessons that will help you see the why, and guidance for you to discover *your* own modern lettering.

I first started lettering because I genuinely wanted to do something besides sit at my computer all day. I needed an outlet. I would come home after my 9-to-5 job and sit on my couch. In front of me was a TV tray stand with paper, watercolors, and scribbles of quotes I connected with. My lettering evolved from:

things are only impossible until they're not TO *things are only impossible until they're not*

And I hope this example helps you see that I didn't always write the way I do now. I learned by doing—and so will you.

As you journey through this book, I can imagine you will hit some bumps in the road. I get it: learning something new is frustrating, and when you don't pick it up right away, it's easier to walk away than to keep trying. *So I ask you to meet me halfway.* Your curiosity got you to open these pages, and that same curiosity is what will keep you going. Give yourself the chance to do something new, open your eyes to the process, and make space to play. And in return, I promise to be there right beside you, green tea in hand, pouring out all of the knowledge I have learned along this lettering journey. My hope is for you to not only learn this art, but also tap into a part of yourself you may never have explored. Feeling a little ounce of freedom from the brush as you draw a beautiful watercolor stroke, learning how to solve problems with tools and write on surfaces you didn't even know could be written on, and finding joy for yourself and sharing it with others—there is something special about writing *by hand* that brings us all closer together and feeling that much more connected. And you know—it can start right here, right now, with you and a lettering tool.

xo, Nicole

How to Use This Book

As you open the pages of this book, ask yourself *why*? Why do the words you see look different from one another? Why does your *a* look different than another person's *a*? Why does one design look unified and another not so much? Continuing to ask the *why* questions will break down what you originally thought was simply the way someone writes.

Next up, ask *how*? Consider the process. How do you make your lettering more than just your "handwriting"? How can a few adjustments help build a cohesive design? How can you make those projects you see on social media with your own modern lettering? Learn the *why*, and then execute the *how*.

This book is designed for you to learn by doing. It's not just a practice handout or something to set on your coffee table, filled with pretty pictures to look at. We'll start with setting you up and then we'll jump right in. **There are thirty-plus bite-size lessons here, each paired with a project.** These are projects that you can customize

and create for your next party, add to your home decor, or personalize as gifts for friends and family. Each allows you the creative freedom to adapt it to your own life, and all of them are made by you—without the need for a computer.

As for the tools you'll be using, the book is broken up into the following three sections: **brush pens, brushes, and pens.** These tools are simply my suggestion to use as we journey through the lessons and projects. They, too, go through a progression. The brush pen can be used the minute you open the cap. Brush painting employs more materials with ink, watercolors, and gouache. And then we add in the world of pens and how to "fake" a lettering style.

The lettering lessons in each section build on top of each other. Section 1 starts with the letters, connecting them, and breaking down several troubleshooting tips to show you the why. Section 2 builds on that foundation, developing your style, creating layouts, and exploring the process of how a small sketch becomes a larger design. Section 3 is where we'll refine, taking a closer look at the little details and how those all add up to shape the bigger picture.

And as you dive in, remember to take it all at your own pace. Keep the work you created in the beginning and continue to ask the *why* questions. These pages are a chance for you to discover the full circle of using those little letters we learned back in school and apply each lesson to a project that feels authentic, personal, and made *by hand*—yours.

Tools of The Trade

The reality is that you can letter with pretty much anything and I understand if the idea of walking into an art store and picking out tools feels overwhelming at the moment. Below is a list of my favorite tools, and the ones we'll be using in this book. In addition, the beginning of each section will go into more depth on the specifics of the tool used in those projects. Feel free to start with these as your home base, but know that by no means do you have to have these exact tools to do the lessons and projects. Starting somewhere is better than not starting at all, and everyone has their own personal preference. I encourage you to try other tools out. There is also a Resources section at the end of the book with other brands, places to purchase these tools, and sources for the project supplies.

WRITING TOOLS

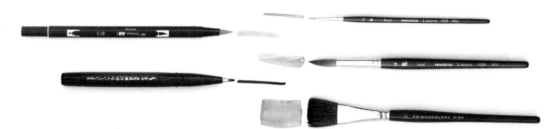

SECTION 1: BRUSH PENS

- **Tombow Dual Brush Pen**
 There are two sides to this pen, however we'll use just the brush side.

- **Pentel Fude Touch Sign Pen**
 This pen is great for beginners and perfect for smaller projects.

SECTION 2: BRUSHES

- **A small round brush**
 Princeton Art Brush Co series 4350 round size 2/0 is my absolute favorite!

- **A larger round brush**
 Brushes come in various sizes and a larger one will come in handy for the bigger projects.

- **A wide flat brush**
 This will be helpful to create watercolor washes.

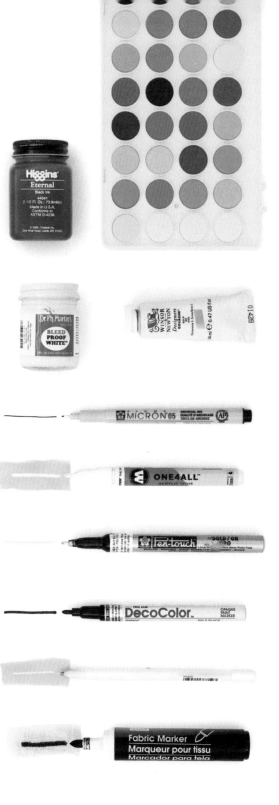

- **Higgins India Ink**
 Look for inks labeled as waterproof, free-flowing, nonclogging, or fast-drying.

- **Watercolors**
 I'll be using a dry watercolor set by Artist's Loft, but there are many options in palette and tube form.

- **Dr. Ph Martin's Bleedproof White**
 This ink is brilliant white, opaque, and writes smoothly. Other white inks may be labeled as calligraphy inks and are great for you to try out. Different white inks will vary in both transparency and the look of the end result.

- **Winsor & Newton gouache— gold and black**
 This is my favorite gold ink. It paints opaque with a slight shimmer. Gouache also comes in many colors and is great for those odd surfaces where other inks bleed and seep into the material.

SECTION 3: OTHER PENS/MARKERS

- **Micron pens** by Sakura of America

- **Paint pens**
 Molotow Acrylic Paint Markers
 Sakura Pentouch Paint Markers
 Art Deco Paint Markers

- **Gel pens**
 Gelly Rolls or Uni-ball

- **A fabric marker**

Aa Bb

Ee Ff

I love you

I love you

I
↓
you

LO
VE
you

I love
YOU

rise
and
shine

PAPER

- **Marker Paper**
 This smooth and slightly transparent paper works well with all types of tools and is the paper I recommend to use throughout the book. This way you can trace over the lessons and come back to these pages to practice all you want. If you don't have any marker paper, tracing paper will work, but know that some brands don't work well with watercolors and the ink will bubble up. My favorite brand is Strathmore 500 Series Marker Paper.

- **HP Premium Choice LaserJet Printer Paper**
 This computer paper doesn't bleed and makes great scratch paper. I suggest having this handy as you go through the lessons.

- **Cardstock**
 Most computer paper is 20 lb.—which is great for practicing. However, most of the projects here need a thicker paper, aka cardstock. Typically those around 65–100 lb.+ will work best for these projects. Cardstock can be purchased in packs or single sheets in every color you can image at craft stores.

- **Watercolor paper**
 When shopping, you'll see both hot- and cold-pressed watercolor paper. Hot and cold are referring to texture: hot is smooth, and cold is slightly bumpy and dries quicker. I personally prefer cold-pressed paper and use the brands below.
 Canson Watercolor Paper Cold Pressed 140 lb.
 Fabriano Bright White Cold Pressed 140 lb.

OTHER SUPPLIES

- Pencil
- Eraser
- Scissors
- Chalk
- Ruler
- Light box—introduction in lesson 5
- Tape
 Washi tape—this decorative tape comes in handy when holding cardstock in position to trace. When removed it won't rip the paper or leave a sticky residue. Masking tape or painter's tape—this tape is best for bigger projects and heavy materials.

Setting Yourself Up

In a perfect world, you have a big studio with a clean table and an endless amount of room for you to spread out. But the reality sitting in front of you may be your coffee table with receipts, to-do lists, and leftover dinner to your right and left. That goes for me too. But hey, you know what? All you need is a little section of a table, a writing tool, and some paper, and you are good to go! Let's get you set up. Below are a few key points to familiarize yourself with.

GETTING TO KNOW YOUR TOOL

Whether you are holding a brush pen or a brush in your hand at the moment, you'll see a tapered point that is thinner at the tip and wider at the base. This shape is the reason we will be able to do all the things we are about to learn. I'll be using the terms *tip* and *belly* throughout this book, so note that these are the aspects of the brush I'm referring to.

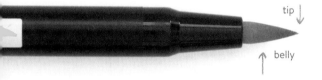

tip ↓

↑ belly

THIN ON THE UP, THICK ON THE DOWN

If you look closely at calligraphy or brush lettering styles, you'll notice that sometimes the strokes are thin and sometimes the strokes are thick. With traditional pointed pen calligraphy nibs, this variance is created as a result of the nib shape. However, we'll be creating the thin and thick strokes by the amount of pressure we apply to the brush pen or brush.

As you draw, apply less pressure when your hand is moving up so the thinner stroke is coming off the tip of the brush. When your hand is moving down, apply more pressure so the thicker stroke is made with the belly of the brush. This will become your mantra: *Thin on the up, thick on the down.* There will be more to come on this in lesson 1.

thin up, thick down

YOUR GRIP

First off, there is not a "right" or "wrong" way to hold your brush or pen. We all hold a pencil differently, so the same goes for these lettering tools. Here are a few suggestions to help you figure out what is most comfortable for you.

Start with how you hold a regular pen or pencil and first try lettering like that. See how that feels for you.

- Ask yourself if you're gripping too tight. I used to be a perfectionist and wanted every single line to be perfect. I would grip my tool so hard that I have this bump near my knuckle which is now a part of me forever (*maybe you're shaking your head because you have the same thing!*). If you too have a death grip, loosen up, and your hands will thank you for it. This way you can transition easier from stroke to stroke.

- At the same time, I suggest avoiding the other extreme of the spectrum with a grip that is too loose. You still want to feel in control of your tool. For example, if you're gripping your tool how you envision a painter would hold a brush, grip a little tighter. Find a happy medium that works for you.

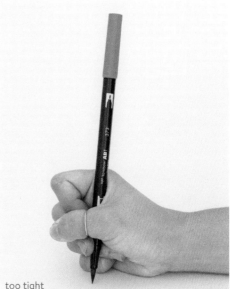

too tight

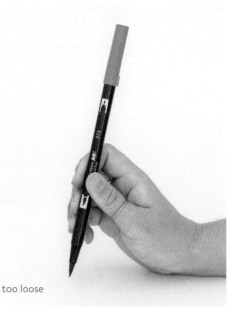

too loose

Play with the placement of your hand on the tool.

- Try moving your fingers closer to the tip of the brush. This can give you more control of the up- and downstrokes.

- Is the side of your hand closest to the paper, floating in the air? Try resting your hand on the table and keeping it stationary.

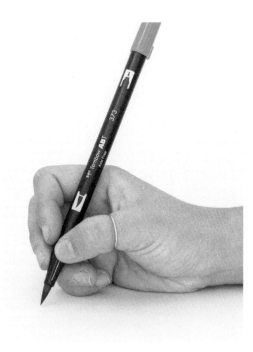

The goal is to feel supported and grounded, allowing you to easily apply different amounts of pressure to create your thin and thick strokes. As you go through these lessons, experiment with your grip and see what works best for you.

YOUR BODY LANGUAGE

I'm not your parent telling you to sit up straight at the dinner table. I hunch over myself—and that's why yoga is my saving grace as I know back problems are in my future. But your posture is something to be aware of when lettering to see if it's hindering or helping you draw.

Try angling your paper, your body, or both. It is harder for me to write with my paper perfectly straight in front of me while I'm sitting up tall. I tend to angle my paper with my body leaning to the left.

In addition, try pushing the paper slightly out in front of you so it's not directly underneath you and sitting too close to your stomach. It will also help to have your elbow supported and resting on the table.

NOTE TO LEFTIES

First off, yes you can! Just because you are left-handed doesn't mean you can't. I've had numerous left-handed students in my classes and personally know several talented calligraphers who are left-handed. From what I've learned from observing, everything is much the same as for my right-handed students. There isn't a set number of rules you have to follow to equal success, and you have to experiment to find what works for you.

Some lefties are *underwriters*, drawing with their wrist straight and lettering from below. If this is you, try tilting your paper clockwise. For *overwriters* who curl their wrist and draw from above, try tilting your paper counterclockwise. Some downstrokes may actually be upstrokes, so do be mindful of that moving forward. I've also seen some people write with the paper completely perpendicular to their body. Find what works for you and don't let your lovely left hand stop you from trying!

WARM UP

Before each section, warm up your hands with a few simple strokes. Draw little blades of grass by pressing down and then letting go at the end. Do this stroke in a few different directions and at different lengths. This will help you to get to know your tool and give your hand a little love before diving into the lessons.

Now, put on your favorite jams and we're ready to rock and roll!

You Have Your Own Mark

As you embark on this lettering journey, I can imagine you'll face a mix of emotions. You may find joy, you may find freedom, and more than likely you will encounter some frustration. Try not to forget that you have your own signature and a special mark to make on this world. Your writing doesn't need to look exactly like mine or another calligrapher you may follow. No two signatures are alike, no two fonts are identical, and no two modern lettering styles should be the same. Use the points I give you to help mold and shape your own style, because you have your own voice, your own look, and your own story to tell. Own that.

We're all human, and just like you, I get frustrated and want to give up and walk away when things aren't going my way. But if we all did that in life, where would we be today? I challenge you to be open to being a beginner and to keep trying. I promise, the first time you give someone something you hand-lettered, you'll know why you pushed through.

Brush Pens

First things first, let's get to know your new friends, the brush pens:

They are handy little tools that can travel with you everywhere—no setup required.

You'll notice a tapered flexible tip that acts like a paintbrush and bends with pressure.

They come in a variety of colors—the Tombow Dual Brush Pens have 96 colors to be exact.

Each brand has its own personality based on the qualities of flexibility and tip size.

- Flexibility

 This affects how much pressure you need to apply in order to achieve different stroke sizes. The less flexible tips feel stiffer and require more pressure to bend. Some of you may prefer this, as it allows you to create a more consistent stroke size and feel more in control of the pen. On the other hand, the more flexible tips bend easier and require less pressure to draw the stroke. This type of tip allows you to have a wider variety of stroke size and acts more like a paintbrush.

 To experience the difference in tip flexibility and see what you like best, I suggest trying out both the Tombow Fudenosuke Hard and Soft tip pens. As for the Tombow Dual Brush Pen and the Pentel Fude Touch Sign Pen mentioned in the Tools of the Trade section—those are both in the middle of the flexibility spectrum.

- Tip size

 This affects the size of the stroke you can expect. Bigger brush tip = the ability to achieve a thicker stroke. Experiment with the ones you have in your toolbox now. For each, draw a stroke applying light pressure, then medium, then heavy pressure and compare the results. Looking at the example to the right, the medium-pressure stroke on the blue Tombow Dual Brush Pen is a similar thickness to the heavy stroke of the black Pentel Fude Touch Sign Pen.

 Knowing this, you can choose which brush pen is best to use. For example, the larger-tip brushes are best for projects that need a thicker stroke to be seen from far away. In comparison, the smaller tip pens are great when you have a small space to work with.

I'll be using the **Tombow Dual Brush Pens** and the **Pentel Fude Touch Sign Pen** for these lessons and projects, but again, please use what works for you. And if you're wondering how to hold the pen, refer back to Setting Yourself Up on page 17 and find what's comfortable for you.

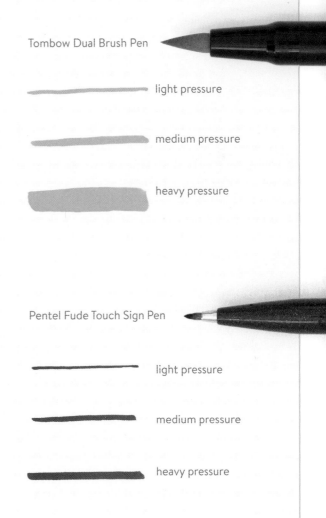

Tombow Dual Brush Pen

light pressure

medium pressure

heavy pressure

Pentel Fude Touch Sign Pen

light pressure

medium pressure

heavy pressure

1

THE FOUNDATION STROKES

[PROJECT: **PATTERNS**]

Here we go! Before jumping ten steps ahead, we're going to start with the foundation strokes. You're getting to know a new lettering tool and breaking down the strokes that make up letters. Setting a solid foundation is essential, but that doesn't mean it can't be fun. We often think of these baby steps as mundane and elementary. But I think we can all agree, kids are the most carefree and play way more than we do as adults. Let's take a page from their book. Grab a moment away from your to-do list, from your work, and let loose with a brush pen. We'll learn the foundation strokes while making fun patterns to pin to your inspiration wall at your desk or frame as new home decor. Grab your brush pen and paper and meet me back here for the lesson. Let's play.

Take a look at the word *lettering* below. Can you see how there are thin and thick parts of the word? Now, try something for me. Move your hand along the arrows and feel as you move up and down. Do this a second time, and as your hand moves in whichever direction, say to yourself, "Thin on the up, thick on the down." This will help you to know when the stroke is supposed to be thin and when the stroke is supposed to be thick. Remember the tip and belly from page 16? Let's put those to good use. When you are drawing and your hand is moving up, use the tip and apply lighter pressure to the paper generating a thinner stroke. When your hand is moving down, use the belly and apply heavier pressure to create a thicker stroke. *Thin on the up, thick on the down.*

art 1:

lettering

lettering

Now, let's jump right in. Each foundation stroke we'll learn here is the back-bone of the letters and will help us moving forward.

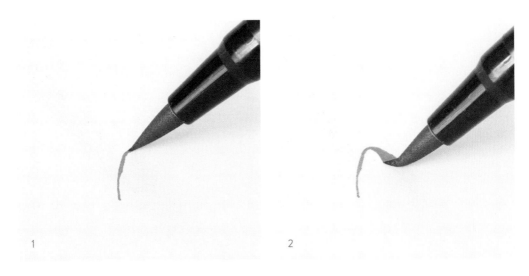

1 2

THIN TO THICK

Using marker paper, trace over the strokes below.

1) Start by drawing a small thin upstroke, applying light pressure.

2) Then as you round the top, start to apply heavier pressure for the down-stroke.

If your stroke looks closer to art 3 than the other examples below, remember to try to use just the tip of the brush pen. Try lightly grazing the paper on the thin upstroke using just the tip. You don't need to be in firm contact with the paper in order to draw the light upstroke. Then once you turn the corner in the stroke, press into the belly of the brush to achieve the thick downstroke. Your hand doesn't change positions; only the pressure increases. *Thin on the up, thick on the down.* The bend in the brush is what allows you to create the difference in stroke size.

art 2:

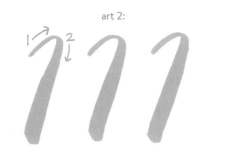

art 3:

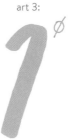

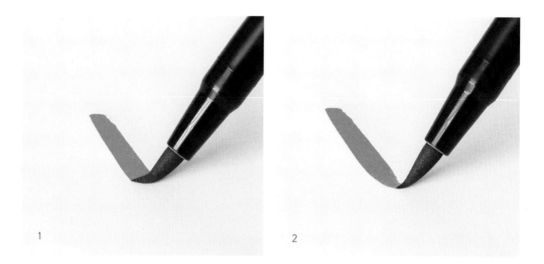

1 2

THICK TO THIN

For strokes that begin with your hand moving downward, draw the opposite: *thick on the down, thin on the up.*

1) Apply heavier pressure on the down using the belly of the brush first.

2) Then as you near the bottom, gradually release pressure as you round the corner. By the time your hand is on the upward motion, you will be on the tip of the brush for the thin upstroke. During the transition, you're not actually lifting your brush pen up off the paper. Think of it as applying less pressure, which raises the belly off the paper to have contact with the tip only.

The key is the transition. It's not thick, and then immediately thin like in art 5; it's gradual. Continue practicing a few rows of these two strokes.

art 4:

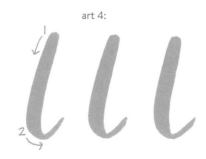

art 5:

THIN TO THICK TO THIN

Next we'll combine the first two strokes together for *thin on the up*, *thick on the down*, *thin on the up*. Rather than thinking of these as three separate strokes, consider them as one continuous and fluid motion with varying amounts of pressure.

1) Begin applying light pressure to create a thin upstroke.

2) As you start to round the top, gradually apply more pressure.

3) Once you are over the hump, apply heavy pressure to create your thick downstroke.

4) As you start to round the bottom, gradually release pressure.

5) Complete the stroke on the tip of your brush pen with a thin upstroke.

As you try this out on your own, you'll see if you don't adjust the amount of pressure you apply and stay on the belly of the brush pen the entire time; your stroke may look like art 7—all thick. You've lost the variation in stroke sizes. Remember, thin on the up with light pressure, thick on the down with heavy pressure, and then back to thin on the up with light pressure. Try these a few more times and be mindful of the pressure.

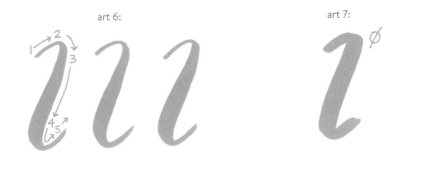

art 6: art 7:

THE L LOOP

Now let's try the *l* foundation stroke with a loop. Using what you've learned from the previous strokes, try this one out on your own first. *Thin on the up, thick on the down, thin on the up.*

As you near the top of the loop, if you find your brush pen is getting stuck, ask yourself where you're starting to apply the heavy pressure. If you're starting too early, your stroke may look like art 9, causing the brush to bend awkwardly and get caught as you make that turn. Next time, wait a little bit longer until you are over the hump before applying the heavy pressure. The arrow on the first practice stroke notes where to start putting on more pressure. Guide the brush to create a smooth transition rather than forcing it to go against the grain of the stroke.

art 8: art 9:

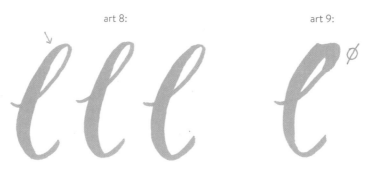

THE J STROKE

On the *j* stroke, do the opposite of the *l*. Start with a thick downward stroke and as you reach the bottom, slowly start to release pressure to transition to the tip of the pen. Then continue the curve with the thin upstroke.

When you are moving from a thick to a thin line, if you release pressure too late, you will feel a similar awkward bend to the tip as you might have experienced with the *l*. This can cause your stroke to be all thick, similar to art 11. And if you release too early, the stroke will look like two disjointed strokes similar to art 12, rather than one smooth stroke.

Instead, trace back over the first examples and use the arrow as your cue to start to release pressure. This will help you move from the belly to the tip of the brush and create the thin line you see here.

art 10: art 11: art 12:

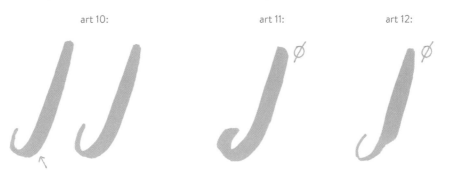

THE ROUNDED C STROKE

This stroke is similar to the *l* but with a shorter upstroke in the beginning. In the same way, wait until you are over the hump to apply pressure for the heavy downstroke. Then as you near the bottom, start to release pressure as you round the curve to get on the tip for the thin upstroke. The arrows here represent when to transition and gradually change pressure.

art 13:

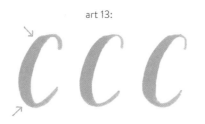

If you start with a thick upstroke instead of a thin upstroke, your stroke may look like art 14. The stroke should be *thin on the up, thick on the down, thin on the up.*

art 14:

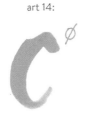

Now try the opposite. This backward *c* stroke is similar to the *j* foundation stroke with an added upstroke at the beginning. It is also *thin on the up, thick on the down, thin on the up,* just in a different direction.

art 15:

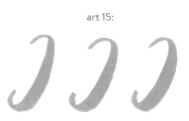

If you're finding any of these strokes heavy at the bottom, similar to art 16, you might be realizing too late that you need to make a thick downstroke. Try again and focus on applying an even amount of pressure on your thick downstroke. Think about being consistent on the actual stroke, but gradual on the curved transitions.

art 16:

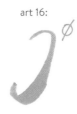

THE ROUNDED O STROKE

With o's you can either start with a thick downstroke (art 17) or a short slightly curved upstroke similar to what we did with the c's (art 18). Either way, know that the o is one of the trickier strokes because it consists of a drastic down and a drastic up. In addition, the extended thin upstroke motion at the end is one we haven't done yet. Practice that stroke now. Draw light upstrokes using the tip of the brush, and see how light you can make them (art 19). Then go back to practice the o strokes all together.

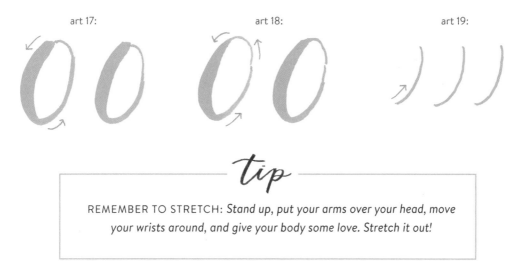

art 17: art 18: art 19:

> ———— *tip* ————
> REMEMBER TO STRETCH: *Stand up, put your arms over your head, move your wrists around, and give your body some love. Stretch it out!*

Patterns

While practicing these foundation strokes, you might as well make a project while you're at it! Take out some cardstock or large sheets of paper. You can cut them into smaller pieces to pin up to your inspiration wall at your desk, frame as wall art, or turn into wrapping paper for use in the future.

SUPPLIES:

brush pen

cardstock

scissors

tape

1) Fill a full sheet with just one of the foundation strokes. Then do a sheet with a few of the strokes. Then try a sheet with all of the strokes. Remember to be mindful of the amount of pressure you are applying. *Thin on the up, thick on the down.*

2) Experiment with your grip from page 17. You may find a different grip gives you more control and is easier for making the transition from thin to thick or thick to thin.

3) Try out another brand of brush pen. As mentioned in the introduction, the brush pens vary in flexibility and tip size. Test out the differences and find which one you like best.

4) Try out another color and have some fun!

5) Finally, cut and then tape or frame some of these patterns up to your walls. It's a reminder that you're doing something new and fun!

2

FOUNDATION STROKES TO LETTERS

[PROJECT: **ABC ART**]

We're not here to learn A is for apple and B is for boy, and this isn't school where you will be told every letter needs to be perfectly written on a straight line. But we are going to use the ABCs to show you how connecting the foundation strokes is why modern lettering is more than just handwriting. We will combine strokes to become letters, and these letters will come together to create a piece of art to gift to a loved one. It's about drawing letters, not writing them.

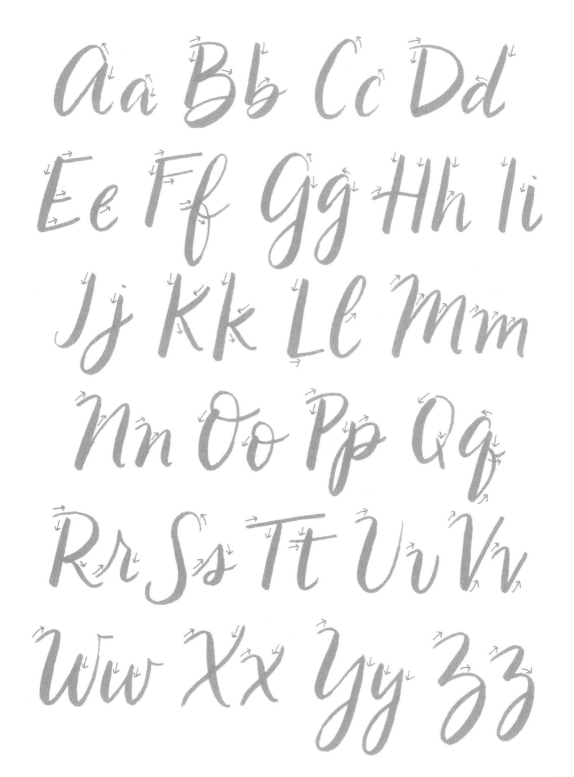

Each letter is made up of a combination of the foundation strokes, as you learned in lesson 1. These strokes are the backbone and basis of modern lettering.

For example, a lowercase *a* is a combination of the *c* foundation stroke + the thick to thin foundation line that looks like an *i*. Try this out on your own. Instead of just writing an *a*, break it down and think of drawing the two foundation strokes close together.

Depending on the style, there will also be times when the letter is an extension of the foundation stroke. For example, a lowercase *p* is the *j* foundation stroke with an extended loop. That extended stroke connects with the backward *c* foundation stroke, which also has an extended end to make a curved loop.

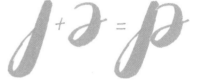

STROKE BY STROKE

Try to look at the letters from a kid's mind-set. Instead of seeing an *a*, see two lines that together form a shape. This will keep your mind from going on autopilot and quickly drawing an *a* because you already know what an *a* looks like. Remember this isn't just about your handwriting.

Grab a piece of marker paper and let's practice. Keeping in mind what you just learned, feel free to trace over the ABCs on page 37. Break them down stroke by stroke as you repeat the mantra of *thin on the up, thick on the down*. The arrows on the ABCs represent two things:

1) The direction to draw in.

2) When to begin a new stroke.

It's a common habit to draw each letter all in one stroke. After all, it's what you learn when taught to write in cursive. However, as you saw even with the foundation strokes, if you draw too fast you can quickly lose the thin and thick variance (art 1). Take it stroke by stroke and break it down. By pausing and lifting up before each stroke, you'll have more distinct thin and thick sections (art 2).

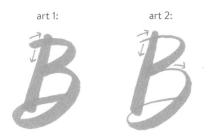

art 1: art 2:

KEEP GOING

If at any point you're not sure which direction to draw a stroke or when it should be thin or thick, ask yourself which foundation strokes make up that letter and flip back to lesson 1 for a refresher. When your hand is moving up, it's a thin upstroke. When your hand is moving down, it's a thick downstroke.

And remember that you're learning a new tool and still getting comfortable with how to use it. Take it at your own pace. If your strokes are jagged and don't look the way you want them to, just draw. Often when you think too much or you're taking it too slow, your hand can shake. Try drawing the letter again, but this time draw with confidence. Experiment. *Keep going.*

ABC Art

Do you have a friend or family member with a sweet newborn? Need a gift for the young one, but don't want to go out and get something at a store? This is the perfect gift to frame and add to a nursery wall. Plus you already have the groundwork from practicing the letters in this lesson. There's no need to go online and buy something when you can make your own gift that you know will mean a lot to your friend.

SUPPLIES:

brush pen

marker paper or cardstock

frame to fit an 8 x 10-inch art piece

scissors

1) Option 1: Cut cardstock the size of your frame and freehand each letter.

2) Option 2: Place a piece of marker paper over the ABCs on page 37. Use this layout as a starting point while putting your own spin on the letters. These letters will fit on an 8 x 10-inch sheet to frame.

3) Remember you're *drawing* the foundation strokes, not just mindlessly *writing* the letters. Use what we learned and draw each stroke one by one. *Thin on the up, thick on the down.* Lightly graze the tip of your brush pen for the upstroke and apply heavier pressure on the downstroke using the belly of the brush. Continue with the full alphabet.

4) Once you've completed your drawing, place the final sheet in your frame. If you are using marker paper, cut white cardstock the same size and place it behind that sheet to give it a solid background.

5) You now have a piece of art, ready to be shared and adorn the nursery walls of a special newborn!

3

THE NUMBERS

[PROJECT: TABLE NUMBERS]

Most likely you come across numbers at some point in your day: the last address you entered into Google Maps, the price on the cash register for your daily coffee, the time on your phone as you set your alarm before you go to sleep. And although these numbers are a daily part of our lives, it is not as common for us to actually write them down on paper. Take a moment to think about the last event you attended. Was it a friend's wedding where you went around to each table catching up with old friends? Or was it a banquet dinner where you sat at a table filled with people in your community? No matter the event, big or small, there was probably some sort of table number sign. And that number may have been written by hand in someone's modern lettering style. Hey, guess what? That someone can be you next time.

In the previous lesson we learned that each letter is a combination of foundation strokes and can be drawn stroke by stroke. The same goes for numbers.

Take out a piece of marker paper and trace over the numbers in art 1. Each arrow represents the direction to start a new stroke. Remember *thin on the up, thick on the down.*

art 1:

1234567890

1234567890

1234567890

1234567890

1234567890

You may have noticed one stroke we haven't focused on yet: the horizontal stroke. We know that up is thin and down is thick, but what is horizontal? There might be a rule, but I say it's up to you. Looking at the two sets of 2, 4, 5, and 7 in art 2 and 3, art 2 has thin horizontal strokes, and art 3 has thick horizontal strokes. Do you gravitate toward one over the other?

Another part of a number to think about is the ends. In the set of numbers 1, 4, 7, and 9 in art 6 each has a hard and flat end at the bottom. To achieve this look, draw the stroke down and then lift your brush pen straight up toward the ceiling. In contrast, if you gradually release your hand toward your body instead, the bottoms will appear tapered as in art 7.

art 2:

art 3:

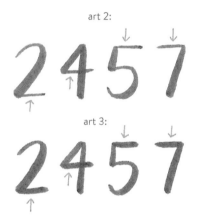

art 6:

art 7:

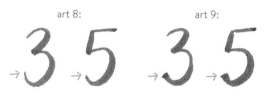

You can also play with varying the thin and thick within the horizontal stroke itself. Sometimes I start the stroke thick and then end thin (art 4), and other times I like to start the stroke thin and then end thick (art 5).

Now let's look at the curved endings on numbers 3 and 5. You can choose to taper the end (art 8) or make a hard stop (art 9). Again, this is up to you and what you like.

art 4: art 5:

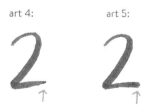

art 8: art 9:

Continue practicing on your own, and use any of the examples on page 43 as inspiration to mix it up. You now have the horizontal strokes, the bottoms, and the ends to think about as you design your numbers.

Table Numbers

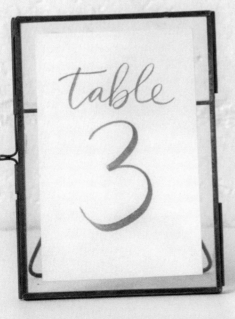

table
3

It's time to put your stylish numbers to use. Table number signs are great for events large and small to differentiate one grouping from the next. "I'm sitting at table 5. Come find me there." Sometimes, you'll see just the number itself, and other times the word *table* *is written above.*

SUPPLIES:

**brush pen
(recommend Tombow Dual Brush)**

cardstock

scissors

scratch paper

1) First, think about your display. Are your table numbers going in frames or standing up in holders? How big do they need to be to be visible to the guests? Cut your cardstock to the size that works for your event and decor. The template here is 4 x 6 inches for reference.

2) Before drawing on the cardstock, practice your numbers on scratch paper and finalize the look of each.

3) Execute. Remember in the brush intro when we experimented with the thickness of the strokes? This is when that comes into play. On the final signs, you'll want the strokes to be thicker than the smaller sketches you've been practicing. I suggest using a larger-tip brush like

the Tombow Dual Brush Pen and applying the heaviest amount of pressure on the downstroke. Then on the upstrokes, instead of applying light pressure, apply medium pressure. This way your thin and thick strokes are proportionate, and you have a thicker number overall.

4) When you're done, place your table number signs in a frame or stick them in the holders, add to each table, and watch as the guests navigate and look for your signs. I'll see you at table 5!

As you draw the thick downstroke using the belly of the brush, take a second to notice your hand positioning in relation to the stroke. Are you drawing from below the stroke or the side of the stroke? Both examples in the images below are using the belly of the brush, however one is thicker than the other. When drawing the stroke from the side, you are able to use the entire belly of the brush to set the width of the stroke and achieve a thicker line than drawing from below.

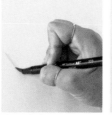

from below from the side

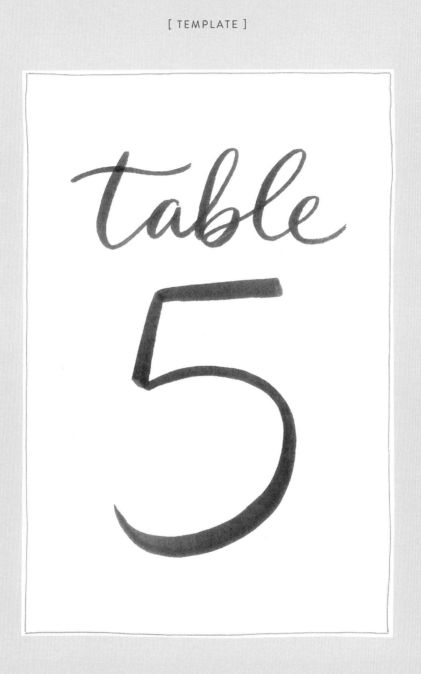

4

THE LETTERS

[PROJECT: **CELEBRATION GARLAND**]

Now that you are officially on this lettering journey, don't be surprised if you find yourself wanting to incorporate it into every part of your life. Do you have a milestone to celebrate or a friend's baby shower coming up? You have the guest list settled, the time and location set, and all you are missing are some decorations. No need to panic, you can make this celebration garland and try out your new skills!

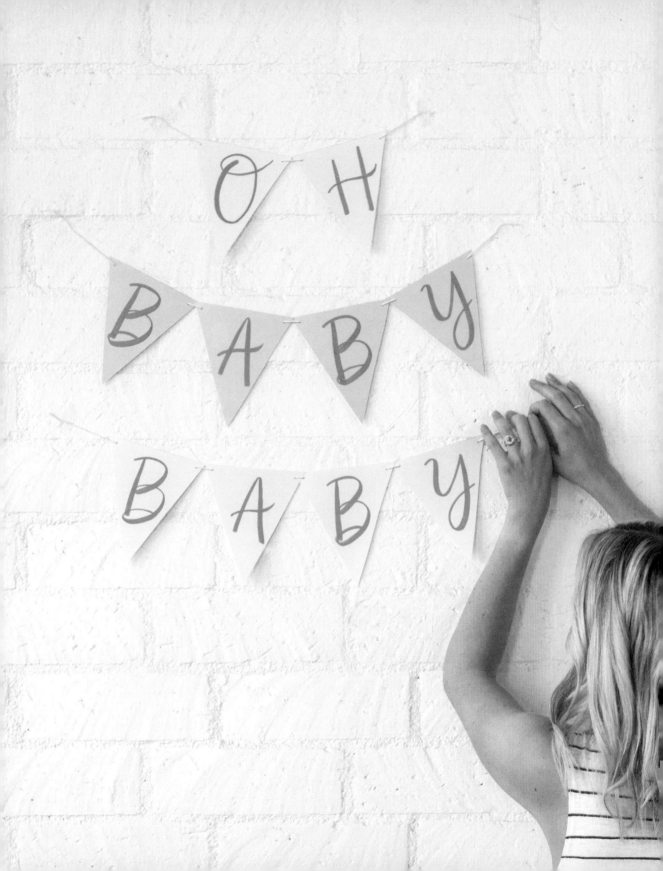

For this lesson, we're going to practice what we've been learning and create a garland. It helps to mix up practicing the strokes and letters all day and try your hand at making something fun. First things first, let's plan out what you want your garland to say. Think about where you plan to hang it and if you envision multiple tiers or one long garland. I'll be using the phrase *OH BABY BABY* for a dear friend's baby shower. A few other fun phrases are: *HIP HIP HOORAY*, *LET'S CELEBRATE*, or *CONGRATS!*

OH BABY BABY

LET'S CELEBRATE

HIP HIP HOORAY

CONGRATS!

Once you have your word or phrase in mind, grab your brush pen and a piece of marker paper or scratch paper. Start by drawing each letter individually multiple times. By drawing the letters a few times, it will help you get comfortable before going to the final piece. Keep going. Explore different ways to write the letters and practice *thin on the up, thick on the down*. Feel free to use the styles on page 37 or in the back of the book on page 253 as a reference.

Celebration Garland

Time to execute. These garlands are a fun way to add decoration to the walls or in front of a table at your next party. Use them to make a statement or personalize for the person or couple you're celebrating.

SUPPLIES:

**brush pen
(recommend Tombow Dual Brush Pen)**

cardstock

pencil

scratch paper

scissors

hole punch

string

tape or tacks

cardboard (optional)

1) Make the template. With a pencil, trace over the triangle template here on scratch paper and cut it out. Feel free to make a cardboard template if scratch paper is too flimsy.

2) Place this template on cardstock and outline the triangle shape. Count how many letters are in your phrase and make that many triangles plus a few extras to give yourself room for error. Then cut them out.

3) Using a pencil, *lightly* draw each letter on the triangles. With your practice sheet out for reference, continue penciling each letter on a triangle until your phrase is complete.

4) Now it's time for the brush pen: draw stroke by stroke over your light pencil lines. Since this garland will be enjoyed from afar, you'll want to make the strokes thicker like we did with the table numbers in lesson 3. Use the heaviest pressure for the downstrokes and medium pressure for the upstrokes. Remember our phrase *thin on the up, thick on the down* still applies even when we are working on a larger letter.

5) Optional: Add any decorative elements: maybe a border near the edge or wavy lines to bring in some personality. Have fun here!

6) Use your hole punch at the top two corners on each triangle and then lay the letters out in order. Thread string either in front or behind the triangle. I'll leave that up to you. Continue threading each triangle, one after the other in order and watch the final product come to life right before your eyes. Now all you have to do is hang it up with tape or tacks and get ready for the party!

P.S. If you wish to use black or really dark-colored paper, you won't be able to see the ink color from the brush pens. However, once we get to the brush projects and introduce white and gold paint, you can come back to this project and make as many garlands as your heart desires!

5

THE
CONNECTION

[PROJECT: DRINK STIRRERS]

We've gone through the foundation strokes, combined them to create individual letters, and in this lesson we'll put it all together to make words: the connection. Think about making a mixed drink or a smoothie. One by one, you put all of your ingredients in the blender, and then mix them together. In the same way, think of this lesson as the blending of your letters. You've built a foundation for yourself going through the first few lessons and have all the ingredients you need to put it together. By the end of this lesson, you'll deserve that drink and will have made stir sticks to go with it!

If you're nervously reading because you'll no longer be drawing individual letters but instead putting it all together, it's okay. This lesson will walk you through how to break the connection down into step-by-step actions. Let's do this!

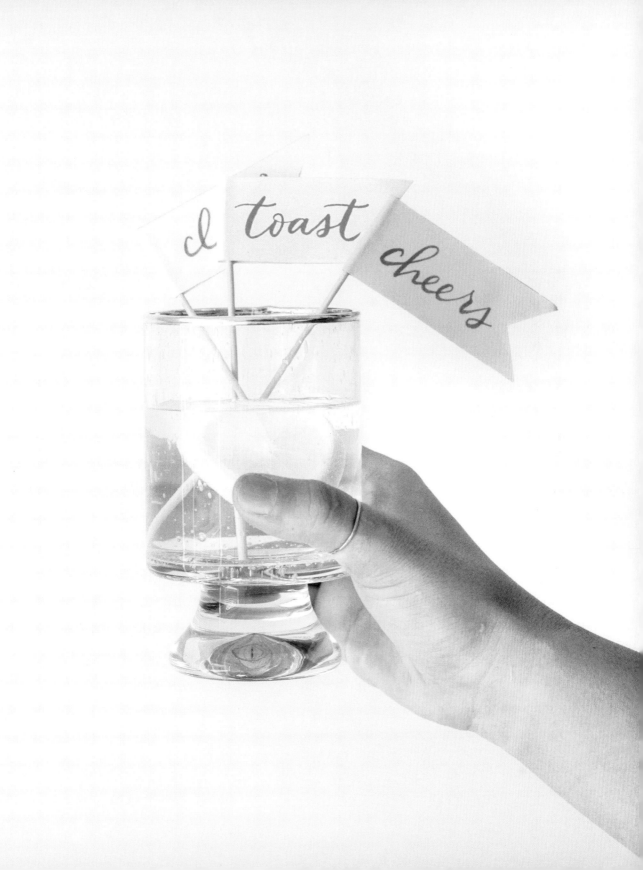

DRAW THE INDIVIDUAL LETTERS

First, with a pen or pencil write out each letter separately with small spaces in between (art 1). There's no need to overthink this step as we're simply setting the foundation. I'll start with the word *cheers* to add to our drink stirrers.

art 1:

cheers

CONNECT THE STROKES

Now for the connection. Look at where the stroke ends on the first letter and the stroke begins on the next letter. Do you see the space between? Fill that space by drawing a connecting stroke.

art 2:

cheers

MAKE SURE THE CONNECTION FLOWS

Flip back to page 25 showing the foundation strokes. Do you see how most of those strokes begin or end in a slightly curved upstroke? Those curves are what we're going for. Instead of drawing a straight line that creates a sharp connection, this time draw the connecting stroke with a curve (art 3). Think of these strokes as rounded *U* shapes instead of sharp *V* shapes. This will develop a seamless flow from one letter to the next.

art 3:

cheers VS.

Let's try another word: *clink*. Start from the beginning and write the letters with space between (art 4). Then add in the connecting stroke (art 5) keeping in mind what we just learned—crafting a curved connection. For the *l* and *k*, continue the connecting stroke up and around to create a loop. This makes the transition smooth and continuous on those tall letters.

Can you see how this connecting stroke is the same as in the *l* foundation stroke in art 6? This is a reminder that the foundation strokes make up each letter and are always there as a good reference as you continue forward.

Think of these connection strokes as the sister to your letters. She wants to grab your hand, lift you up, and support you as you flow from one letter to the next. The end of one letter becomes the beginning of another.

art 4: *clink* art 5: *clink* art 6: *l*

PUT IT ALL TOGETHER

Now that you have your foundation set, let's draw the full word out with a brush pen. Place marker paper on top of your connected words from the previous step and trace what you see underneath. Draw stroke by stroke, connect the letters, and remember to focus on *thin on the up, thick on the down.*

Then take a step back and look at what you created. You went from a pencil sketch of individual letters to this brush lettering piece. You did it! These steps make the process of connecting less intimidating and know this lesson is always here for you to come back to. And as you get more comfortable, you'll start to write the words without having to break it down into individual steps.

tip

The pencil is your friend. If you immediately write a word out using your brush pen, it can be overwhelming to think about the connections and figure out if the strokes should be thin or thick. Find the connection first with a pencil and then go over it with a new sheet and your brush pen. Focus on one thing at a time. Find the connection, then figure out the thin and thick.

Drink Stirrers

cheers

sip

cheers

clink

toast

Ready for that drink? Let's make some drink stirrers to go with it!

SUPPLIES:

brush pen

pencil

cardstock

scissors

bamboo sticks or thin wood dowels

double-sided tape

scratch paper

light box (optional)

cheers | cheers

clink | clink

toast | toast

1) Trace the flag template from page 59 on scratch paper. The dotted line indicates where to fold your paper in half to wrap around the stick, so sketch in your connected word in pencil on both sides of the dotted line. A few ideas for what you can write are: *cheers*, *clink*, *sip*, *toast*, and *hooray*! You now have your full template.

2) Now let's eliminate the step of drawing the words in pencil directly on the cardstock like we did in lesson 4, and use a new tool: a **light box.** A light box contains a light source that shines through a semi-clear top so you can see what is underneath your paper. When we place the template you made in step 1 on the light box and your cardstock on top of that, light will shine through both sheets giving you the ability to trace and use the brush pen. If you don't own a light box, all you need is something with a bright enough light source to shine through your template sheet and your cardstock when placed underneath them. An iPad, a tablet, or even a little sunshine through a windowpane will work if you feel comfortable working standing up and writing vertically.

3) With your light box on, lightly trace the banner outline in pencil to know where to cut in step 4. Then use your brush pen to trace over the word you drew in step 1 directly on the cardstock. Since these flags are smaller, you can either use a pen with a smaller brush tip like the Pentel Fude Touch Sign Pen or press lighter on the Tombow Dual Brush Pen to create a thinner stroke.

4) Continue making more. When the page is filled to your liking, cut the flags out along the outline.

5) Flip each flag over and add double-sided tape to the back. Use one long strip that covers the full piece and then a few small pieces along the ends so they stick nicely together. Scrapbook tape in a dispenser is a handy tool for this.

6) Fold each banner in half around the top of a bamboo stick and press both sides to adhere together.

7) Now go make yourself a drink—and cheers to you!

A light box is a handy tool to avoid those pencil lines from showing up on your final product. Draw, erase, and work through your pencil sketches first on scratch paper. Then with a clean piece of cardstock, turn the light box on and trace with a brush pen. You will have a beautifully clean drink stirrer and can make more without having to remake the template over and over again. Double win!

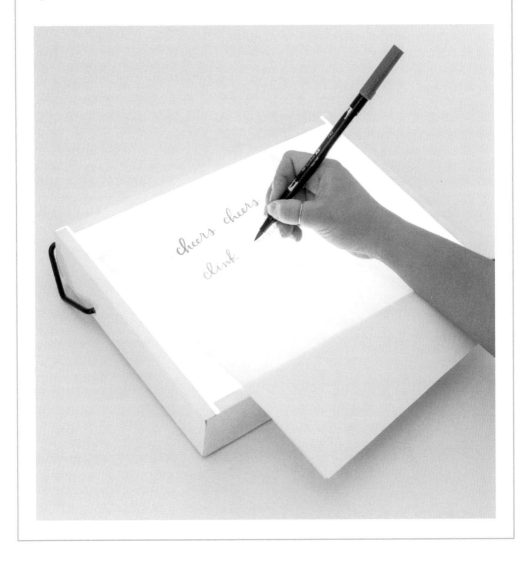

6

THE WORDS

[PROJECT: CAKE TOPPER]

Let's take a trip down memory lane and think back to elementary school when you first learned cursive. If you've blocked that out of your memory or you didn't learn cursive in school, don't fret. I'm here to actually ask you to unlearn what you may have been taught in school! Cursive is the connecting of letters and often used for the purpose of writing faster. Think of your signature: you're handed a pen to sign a check at a restaurant, and—whoosh—one stroke and you're done. With modern lettering using cursive is more about intention than speed—mindfully layering the foundation strokes to make up the whole word. Think of these strokes as the layers of a cake. When one tier is put on top of the other, several layers create a beautiful cake. And of course, you can't forget, every cake needs a cake topper no matter what the celebration is!

Now that you're familiar with connecting the letters from lesson 5, let's continue creating words. With your brush pen, write out the word *let's* without thinking about anything. Now write that same word taking it slower. Then write it one more time, but think about lifting up your pen after each stroke; *thin on the up, thick on the down.* Can you see the difference?

art 1:

art 2:

art 3:

When we begin to connect the letters, we often go on autopilot and write the word all in one stroke (art 1). In addition, since the focus is on connecting the letters, it's easy to forget to apply different amounts of pressure to make thinner and thicker lines

(art 2). The goal is to have your strokes look similar to art 3, with light pressure on the up, heavy pressure on the down.

If you're feeling a little overwhelmed let's revisit how to connect the letters. Remember in lesson 1 when we started with the foundation strokes? There was a reason for that. Take a look at art 4. Each one of the foundation strokes makes up each letter in some way.

art 4:

When you extend these foundation strokes to reach to the next letter, you can see the word starting to take shape. These extensions are the connecting strokes we learned in lesson 5. Now try and rewrite *let's* lifting up your pen after each stroke. The arrows in art 5 represent a new stroke and when to lift up your pen.

art 5:

By taking it stroke by stroke and not rushing through the word, you are able to focus and apply different amounts of pressures. *Thin on the up, thick on the down.*

Let's try another word: *party*. As you draw it out, you might notice one of two things happening with the *t* connection. In art 6, the connecting stroke from the *r* to the *t* ends lower, whereas in art 7, the connecting stroke ends higher, closer to the horizontal stroke of the *t*. Neither is right or wrong; these are just differences in style to notice. The only thing to be mindful of is to avoid creating such a wide *t* connection that it starts to look like a different letter. Art 8 is an exaggeration, but you get the point. This *t* could be interpreted as a capital *A*.

Continue practicing on your own, and feel free to trace over the words below. The arrows represent the direction to draw and when to lift up and start a new stroke. Remember we're drawing the foundation strokes, not just the letters. For example, the *y* consists of a *u* foundation stroke and a *j* foundation stroke and is drawn in two strokes rather than one. Please know, this isn't a hard-and-fast rule. You can lift up your brush pen as little or as often as your heart desires. Knowing the foundation strokes will simply guide you to focus on the strokes and be more mindful of the thin and thick.

art 6:

art 9:

art 7:

art 8:

Cake Topper

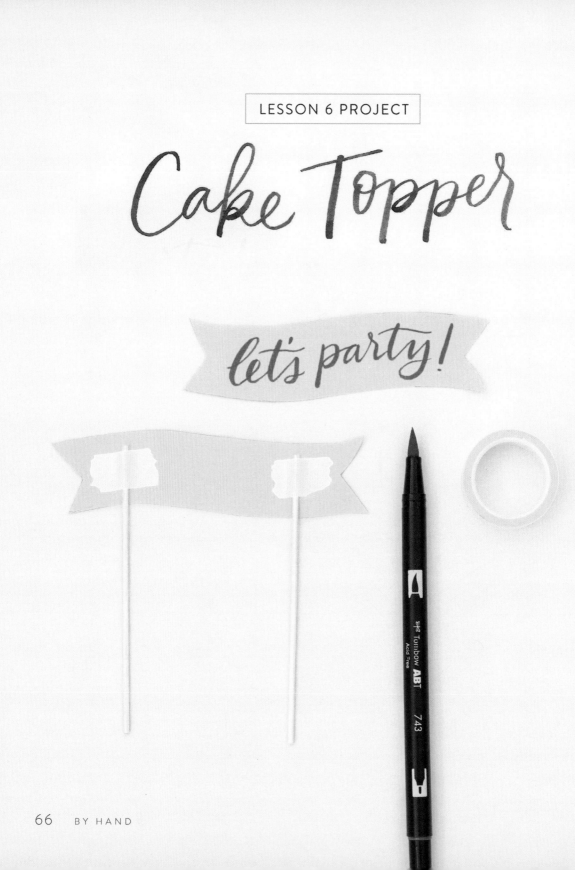

let's party!

Have a dessert that needs some decorations? Don't have time to get some candles? That's okay: you can quickly make your own! Use any of the words in lesson 6 or come up with your own phrase to save the day and make a cake topper with your lettering on it.

SUPPLIES:

brush pen

cardstock

light box (optional)

2 thin dowels/bamboo sticks

scissors

tape

scratch paper

pencil

1) First trace the banner template on scratch paper and write out your word in pencil. This is your template.

2) Place your cardstock over your template on a light box to see the words to draw. Lightly trace the banner outline in pencil, and then using a brush pen, trace over your word(s). *Thin on the up, thick on the down.*

3) Cut the banner out along the pencil outline.

4) With the banner word(s) facing down, place 2 sticks on the right and left sides, and put tape over them to secure them to the cardstock. If your sticks are too long, cut and/or bend them to make them shorter. Or if you don't have any sticks handy and your cake is small, toothpicks will totally work too!

5) Poke the sticks inside the cake and you are good to go. Time to celebrate and dig in!

[TEMPLATE]

let's party!

Be Present

First off, here's a big high five to you! I know that was a lot of information to take in, and this may be a completely new way of looking at those same twenty-six letters we use to communicate every day. Learning to lift your pen after each stroke takes focus, discipline, and patience. And it is tempting to go fast and rush through a word because you just want to get to the end. It's that instant gratification problem.

We can be tempted to rush through life as well. Work, meetings, social events, family, parties, cleaning the house, doing the dishes, washing the laundry—I think you get where I'm going. Life gets busy, and we end up sprinting from one thing to the next. We cross off an item on the to-do list, but then add five more. We fill our calendars and then stuff in even more activities. It doesn't stop and neither do you.

Pause. Come up for air.

Everything will still be there. Look at what you have right in front of you and what you are creating. You are making something by hand with modern lettering. If you simply go through the motions, get frustrated, and rush through to finish, you're missing out. You'll be creating from a space of just getting it done, instead of remembering the why. Take a moment to breathe, to make space, to collect your thoughts, to evaluate, and to face the next moment. Then press play. That's where you'll grow.

7

THE SPACE BETWEEN

[PROJECT: **NOTEBOOK**]

When we look back at our lives, we often think of the big moments, milestones, and birthdays—our best friend's wedding, the day we graduated, the birthday that gave us the ability to do "adult" things. But what about the moments in between? What about the late nights laughing with our friends watching YouTube videos, the days grinding at the library with head down and headphones on while studying to pass that last final, your first kiss, your first heartache? All of those moments in between are just as important as the big milestones, and when we look back, they are what shaped us to be who we are today. These moments you'll want to remember as well.

As we make a notebook and a place for these memories to live, I ask you to also think about the space in between your own letters you'll be drawing. They too are telling a story that shapes the bigger picture.

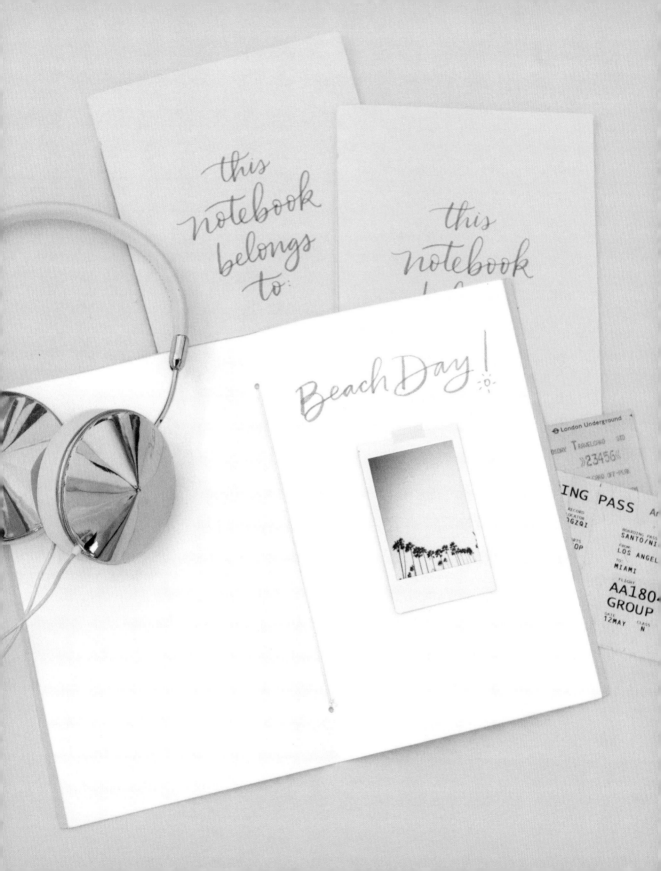

Let's start with the word *notebook*.

art 1:

notebook

Looking at art 1, even though *notebook* is one connected word, *note* and *book* feel like two separate and distinct parts. Why is that? Take a closer look specifically at the space between each letter. We will be focusing on this negative space in this lesson. I'll draw circles in these spots in art 2 so we can really see their shape.

art 2:

notebook

Notice that the spaces between the letters in *note* are bigger and more circular than the spaces between the letters in *book* which are smaller and more oval. Because these spaces in between aren't consistent, this *note* and *book* look like two separate words instead of one *notebook*.

Let's try again and rewrite the word, making sure all of the spaces are similar to the circular gaps in *note*. We'll do this by opening up the negative spaces in *book* so those letters aren't as close together. If you have marker paper, this is a perfect time to use it. Place the paper over art 1 and write out *note* the same way. Then after drawing the letter *b*, leave more room before you draw the first *o*. Eyeball the space—it doesn't need to be perfect. Continue with the rest of the word, opening up the spacing in between the remaining letters. When you are done, compare this to our first effort. The new word is less disjointed and more cohesive because the spaces in between are all the same size.

art 3:

notebook

Now, what if we did the opposite? Rewrite *notebook* again but tighten the circular spaces between the letters in *note* to mimic the tighter, oval shapes in *book* from our first sample. As you can see, the end result in art 4 also feels like a unified word. Both our second and third attempts are great. It doesn't matter if the shape or amount of space between the letters is circular or oval; what you're striving for is to have the spaces stay consistent.

art 4:

notebook

Try drawing this word again on your own. Pick the version of *notebook* you prefer and write *this* and *belongs to* framing *notebook* above and below with similar attention to the spacing between the letters. Looking at the two samples below, the letters themselves are the same, but the spacing is different. Experiment.

art 5:

this notebook belongs to:

art 6:

this notebook belongs to:

tip

TROUBLESHOOTING TIP: *The space between the letters is something to be mindful of. If your word feels off and you can't tell why, check your spacing. When the spaces are consistent in size, the word will feel more unified.*

Notebook

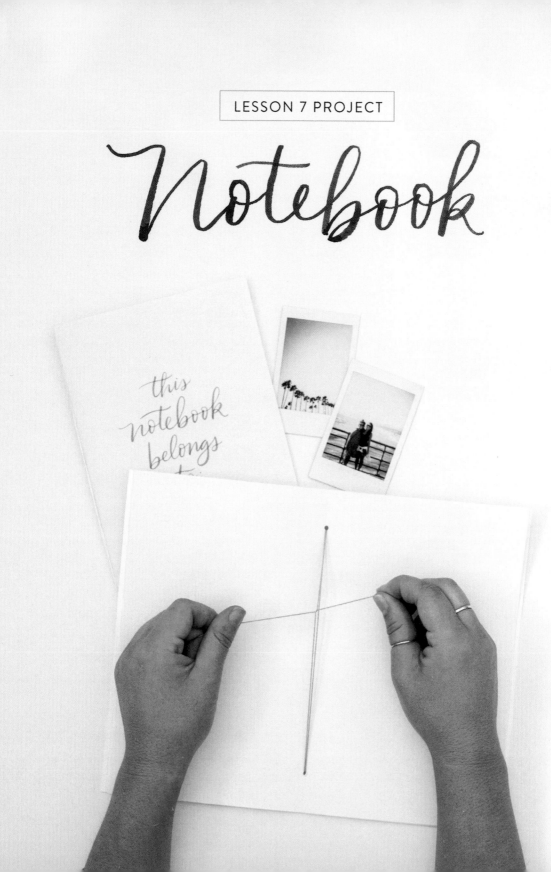

Time to put your skills to the test. Let's make a place for you to capture and keep those memories.

SUPPLIES:

brush pen

pencil

1 piece of cardstock

3+ sheets of computer paper

light box (optional)

small hole punch

string

scissors

scratch paper

1) To make your own notebook, take a few pieces of computer paper and one piece of thicker cardstock. If you can, I suggest making the cardstock cover slightly wider than the computer papers. Place the cardstock on the outside and fold all of the pieces in half inward. This will make a 5.5 x 8.5-inch notebook. Put this aside for now.

2) Make your lettering template for the cover. Trace the size of your notebook on a scratch piece of paper and plan out your design. You can take the lettering you did earlier for *this notebook belongs to:* and draw it out on your template.

3) Open up your cover sheet and place the front right side on your lettering template on top of your light box. Use washi tape to hold the cover in place. With the light box on, trace the words on the cardstock with your brush pen. Take this stroke by stroke and remember *thin on the up, thick on the down.*

4) Once that's complete, add the cover back to the outside of the computer sheets and open them all up. Punch two sets of holes on the fold. The first should be about an inch from the top and the second the same distance from the bottom. If the paper is too thick, punch holes in the computer papers and cardstock separately.

5) With the papers back together, thread string through both holes and tie a knot on the inside.

6) You now have your own special place to hold all of those wonderful memories that are personal to you. Enjoy reliving them and capturing new ones!

7) Bonus project: Repeat and make more to give to your friends and family!

8

THE ANGLE

[PROJECT: **DESSERT SIGNS**]

You get excited and jump up and down because the party has all of your favorite desserts. You're standing tall. An hour later you're hunched over in the back corner of the party because you had one too many desserts. You're leaning over. Then you get your second wind and go back for more. You're standing tall. I think you know how the story ends: you're leaning over.

Have you ever thought of your letters as either standing tall or leaning over? You're probably familiar with making a font italic on the computer but might not have thought of your own letters in this way. We can start now.

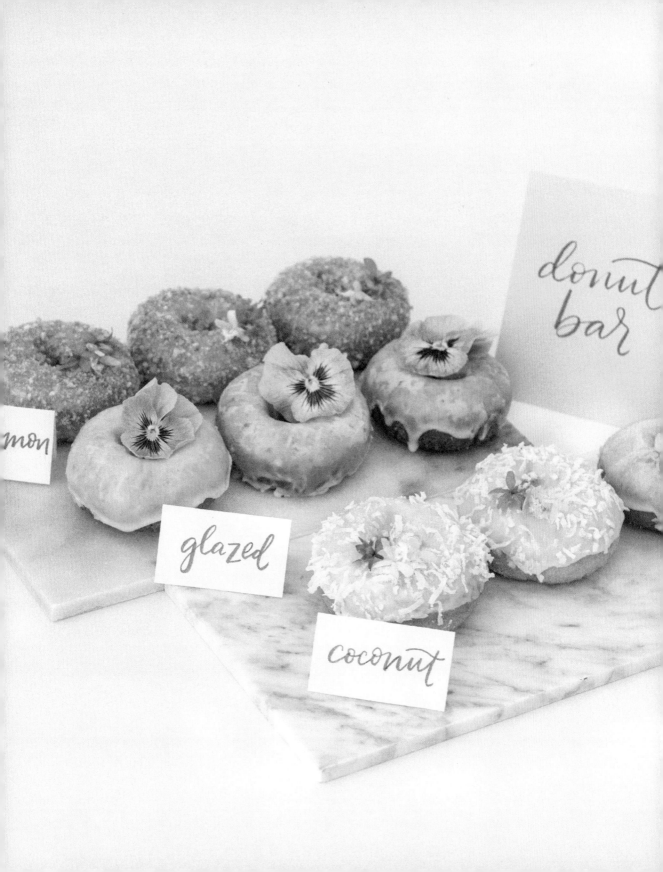

I'd like you to play teacher for a second. Put out in front of you any of the words you've been writing on your own. Do some of your letters look like they are leaning over while others are standing up straight? Use a different color pen and draw lines to mark the angles of each letter.

Now take a look at donut below in art 1. Something about this word feels off. When broken down, the marks reveal that the angles are all over the place. The d, o, and u are slanting to the right (pink), while the n and t are standing tall (blue).

art 1:

Now compare art 1 and art 2. Can you spot the difference? I changed the angles on the n and t, so they too are written at a slant to mimic the d, o, and u. With these small adjustments, all of the letters are now on an angle and the whole word *donut* looks more cohesive than the first attempt.

art 2:

On the flip side, if you want all your letters to be straight and standing tall like the n and t in art 1, change the angle of the d, o, and u to straighten them up with vertical strokes to match.

art 3:

Although art 2 and art 3 may have different angles from each other, within the word itself the angles are the same. This is what matters. It is not a certain angle that makes the word "correct"; as long as they are consistent within the word, your letters will look unified.

Now you may be thinking to yourself, "Okay great, I can see the angles she is talking about, but how do I make sure that *my* letters stay at the same angle when actually lettering?" If you flip to page 255, you'll see a page with angled lines. Use this underneath your paper as a guide to help you stay on track. The strokes do not need to fall perfectly on the lines, but staying parallel to the guide will help you keep your slant consistent.

Dessert Signs

cinnamon

glazed

coconut

lemon

maple

chocolate

sugar

Do you have an event coming up and need to tell the guests what they are eating? Tent cards are a quick and easy way to get the job done.

SUPPLIES:

brush pen

cardstock

scissors

scratch paper

1) Cut and fold your cardstock in half to create tent cards. The size is up to you and may depend on the height of the stand the desserts are on. The ones in this picture are 2.5 x 3 inches folded down to make tent cards with a display area of 2.5 x 1.5 inches.

2) Keeping your angles in mind, write out your items on scratch paper first. Be your own teacher. Are your angles consistent? If not, how can you adjust them? Find the angled template on page 255 and place it underneath your paper as a guide.

3) Now, without a light box, I want you to write directly on the tent card with your brush pen. You have your practice words from step 2 for reference. And if you make a mistake, these tents cards are small and you can easily make more. You can do this!

4) Easy as pie. Well, I don't think pie is easy to make—so easy as buying a donut! Place each sign next to the item it is describing and take a sample. You certainly have to test it out to make sure you put the right card with the right dessert, don't you?!

tip

TROUBLESHOOTING TIP: *Moving forward, if you find yourself looking at a word you have drawn and wondering why it seems off again, remember this lesson and check the angle of your letters. Make adjustments based on what you uncover, and that may be what gives your word a more cohesive feel.*

9

PLAYING WITH THE ANGLE

[PROJECT: MENUS]

Naturally, when you host a dinner party or have a gathering, your guests are at the front of your mind when figuring out the menu. The food stays essentially the same, but there are a few ingredient changes you can make to cater to their needs. Do they have any dietary restrictions? Do they like things spicy, not spicy? Is there anything anyone absolutely despises?

In this same way, let's think about how you can cater your letters to your guests. In this lesson, we'll continue looking at the angle of your words and how that affects the end result. Just like altering your menu, you can also change the angle of your letters to create something new.

menu
tacos:
carne asada
pollo
fish
veggies
—
salsa +
guacamole

Now that you have an understanding of the angles and keeping them consistent from lesson 8, let's take a step back and get in touch with your feelings. Not a feelings person? That's okay, this project involves food so you can treat yourself by the end.

art 1:

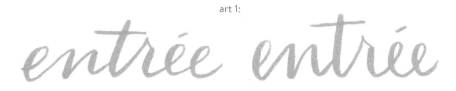

Do the two styles of the word *entrée* in art 1 feel different to you? Is one a bit more elegant and one more youthful? Or do you see one fitting a black-tie wedding affair more than a Hawaiian beach barbecue? There isn't a right or wrong answer. This is simply an exercise to show that, although the word itself doesn't change, by altering just the angle, you can give it a different personality.

Let's say you are hosting a dinner party with Mexican food on the menu. There is a kids' table and an adult table—same food, different decor. The kids have plastic plates; the adults have terra-cotta plates. The kids have succulents as their centerpieces, and the adults have mini cactus plants—no kids will be getting poked at this dinner party! In the same way you made these decisions on the decor based on who you are serving, let's cater the menu lettering to your audience as well.

Comparing the two menus side by side on the next page, you can see the basic letterforms are the same. The only difference is the angle. The lettering on the left slants more, and the lettering on the right is standing tall; each has its own personality. You have the freedom to decide which style fits your guests best. Just remember to keep the angles consistent as we learned in lesson 8.

menu

tacos:
carne asada
pollo
fish
veggies

—

salsa +
guacamole

menu

tacos:
carne asada
pollo
fish
veggies

—

salsa +
guacamole

tip

If your tendency is to write more straight up and down but you want to write at an angle, try something for me: Place a piece of marker paper on top of your original word with the vertical lettering. Follow your same basic shapes but draw the downstrokes slanted instead of upright. The light gray art below is the original menu written straight up and down and the turquoise menu on top is the word angled with the downstrokes adjusted. Doing this exercise will train you to focus on the strokes and slightly angling them. In addition, feel free to use the angled guides on page 255 underneath your words to stay consistent.

menu

Menus

Are you ready to set the table and make your dinner menus? What will you choose: straight up and down lettering, angled lettering, or something in between? Below are a few tips to help with the layout.

SUPPLIES:

brush pen

cardstock

grid paper

light box (optional)

scratch paper

pencil

scissors

washi tape

1) When creating a layout that has several lines, I like to use grid paper as my template instead of a blank page. This helps to keep the amount of space between each item even. See page 257 for blank grid paper that you can photocopy and use as well.

2) Option 1: In pencil, draw the menu items directly on the grid paper. The grid lines are also handy if your letters are standing up straight.

Option 2: If your words are angled and the grid paper is confusing, make another template using scratch paper. First draw the lines where you want to write each item. Then place the angled grid lines from page 255 underneath your template. Draw out your words at an angle using the angled grid as a guide.

3) Once your template is complete, cut your cardstock. Place both the cardstock and your template over the light box and use washi tape to hold the cardstock in position. Washi tape is a decorative tape that can be easily removed without ripping the paper and doesn't leave a sticky residue.

4) With the light box on, use your brush pen and trace the menu directly onto the cardstock. Focus on drawing stroke by stroke. *Thin on the up, thick on the down.*

Repeat this process if you're making more menus.

5) Then set the table, place your menus on the plates, and enjoy your dinner party with friends and family!

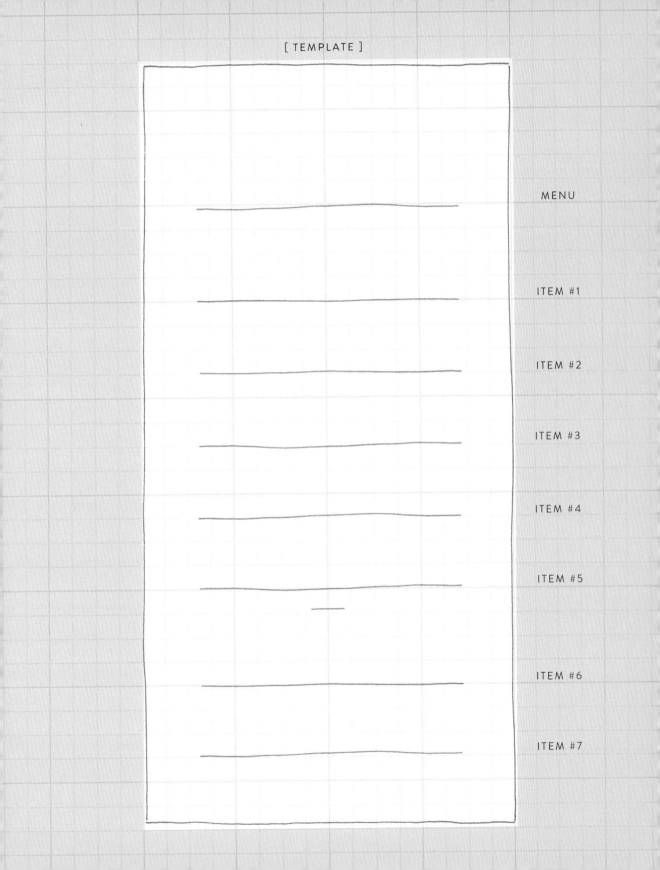

MENU

ITEM #1

ITEM #2

ITEM #3

ITEM #4

ITEM #5

ITEM #6

ITEM #7

10

THE SHAPES

[PROJECT: **STICKERS**]

Stickers come in all different shapes and sizes. Some are circular, some are oval, some are blank, and some have cool borders. You can stick them on favors for your next party, use them to seal your kids' lunch bags, or place them as little reminders on your planner.

Just like how stickers come in different shapes and sizes, so too does modern lettering. Your words can be circular or oval, tall or wide. We'll use the idea of shapes in this lesson to break down words and show you yet another way to create different styles for your own modern lettering.

Let's review what we've learned so far: the foundation strokes, the letters, connecting letters, and in the last few lessons, keeping the space between the letters and the angle consistent. Now, to add another idea to the mix, we're looking at the shapes of your words. And by that I mean the shape your letters are forming. Here's an example, the letters for *shine* in art 1 are formed as ovals whereas those for *shine* in art 2 are more circular. The strokes that make up these letters are exactly the same; however, the shapes that they are forming are different. That is why the two look different.

art 1:

art 2:

shine

shine

shine

shine

Now I'd like you to put that teacher hat back on for a second and draw either ovals or circles over a few of your own words.

What shape are your letters creating? Do you notice a trend throughout your words?

Often you'll have a natural tendency with the shapes you use, and most likely you haven't even been aware of it. Mine tend to be angled skinny ovals, whereas yours may be straighter up and down circles. Neither is right or wrong. This exercise is to show you another way to explore and develop your own style. Remember you don't have to stick to just one.

Here's another example. If you look specifically at the o's in *love* in art 3 and art 4, you can clearly see the difference. The o in art 3 is circular, and the o in art 4 is oval. Knowing this, try out another word with an o, and match the same shapes (art 5).

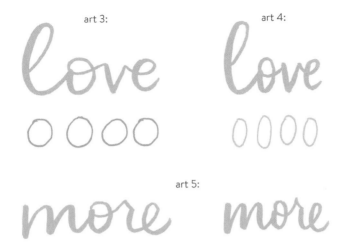

art 3:

art 4:

art 5:

Take some time to play around and explore different ways that you can change the shape of your words. Maybe start by writing your word with circular shapes (art 6), then angle and make them oval shapes (art 7). Take it a step further and make tall, skinny, and angled ovals (art 8). You'll start to discover how you can transform what you thought was just "your handwriting" into fun designs that can be catered to any celebration.

art 6:

art 7:

art 8:

Stickers

With a quick peel and press, stickers are a fun and easy way to add a personal touch or a little pizzazz to anything and everything. Craft stores have blank stickers with borders, or if you're looking for completely blank stickers like the ones on the gummy bear favors on page 89, check out the Resources section for online sites to purchase.

SUPPLIES:

brush pen

stickers

scratch paper

1) If you want to practice first, trace the sticker shape on scratch paper. Experiment with different shapes for your letters (oval vs. circular) to see which one you like best for this project.

You might come across a longer word that you want to fit in a small shape. For example, in order to fit *thanks* in the circle, the letters will need to be more oval (art 9), whereas with a wide sticker you can draw the word with more circular shapes (art 10) or you can still keep the ovals but have more white space around the word (art 11). It's not necessarily about making the letters bigger; think more about the shape of your letters.

art 9:

art 10:

art 11:

art 12:

art 13:

Another example using different shapes is *you rock!* Can you see the difference? Art 12 has letters more circular in shape, and art 13's letters are more oval. The letters are the same size, but different shapes.

2) To letter on the stickers, either use a light box to trace your template underneath or draw it freehand and go for it. If your stickers are small, try using a smaller brush pen. My personal favorite for this type of project is the Pentel Fude Touch Sign Pen used in the photo on page 92.

3) Repeat with any other words or phrases and then stick away!

BRUSH PENS:
IN A NUTSHELL

REMINDERS

- Thin on the up, thick on the down.

- Apply light pressure using the tip of the brush pen for the thin upstrokes and heavy pressure using the belly for the thick downstrokes.

- Letters are made up of the foundation strokes (lessons 1 and 2).

- When connecting letters, the end of one letter becomes the beginning of another (lessons 5 and 6).

- Use the angles (lessons 8 and 9) and shapes (lesson 10) of your letters to develop and mix up your style.

TOOLS

- The brush pens (intro to brush pens section).

- The pencil is your friend.

- Marker paper—slightly transparent paper that is great to overlay as you build your words out.

- A light box—allows you to see through thicker cardstock that isn't naturally see-through (lesson 5).

- Angled grid paper—helpful for drawing your words at a consistent angle (lesson 8).

- Grid paper—useful for layout purposes to keep the space between the lines of text even (lesson 9).

TROUBLESHOOTING TIPS

If you find yourself looking at your words and wondering why they feel off, use any of following tips.

- Lesson 7: Make sure the spaces between the letters are consistent in size. It doesn't matter how big or small the space is, just that they are consistent through the word.

- Lesson 8: Check if the angles of your letters are the same for the whole word. Are you drawing your strokes straight up and down or slanted?

THE LIFE OF BRUSH PENS

- Like any other pen, eventually these will dry out. Take this as a friendly reminder to close the cap tight.

- Over time the tip will become dull and lose its point. Because of this, your thin strokes will become less thin. It is up to you when you want to get a new one, but just know that this is normal wear and tear. Using paper with texture will shorten the life span of a pen tip, and it will become dull quicker.

Shifting Perspective

As we go through these lessons, my hope is that you're starting to look at letters a little differently. This isn't just penmanship, and there isn't simply one way of doing modern lettering. By making small adjustments, you can create different impressions and change the story your words are telling. Change the angle, open up the spacing, and shift the perspective.

When things in life get hard, we tend to get tunnel vision. "Why would she say that?" "Why didn't you learn the last time this happened?" "Aren't you better than that?" Just like with my letters, I had to learn to shift the angle and shift my perspective in daily life—to replay a conversation or situation from the other person's perspective, to see mistakes as learning lessons rather than failures or setbacks, to change the way I talk to myself and see the bigger picture. Making these small adjustments creates a different way of showing up in the world.

When you are going full steam with your head down and blinders on, it's hard to see what's going on around you. With your modern lettering you can trace the same word over and over again, put the practice in, and still not feel like your lettering looks the way you want it to. Take a step back. Yes, it is important to create muscle memory, and I highly recommend that. But also do yourself a favor and allow the space for you to think and evaluate. Take the blinders off. Why don't you like the way your lettering looks? Is there a stroke you can alter that might be different than the others? What can you change in order to make a word more cohesive? Remember you have all the troubleshooting tips in this book to help you see things from a new perspective. And when you know the why, you can decide to make a change. Tell a new story and shift the perspective.

Brushes

The next tool to add to your toolbox is the brush. Although similar in shape to the brush pens, the brush is a little different because of the fact that you have to add ink to it. It's not just *pop open the cap and use right away* like the brush pens.

However, this allows you to choose what to paint with and adds a whole new world of possibilities. From ink to watercolors to white paint and gold gouache, using a brush, although more challenging in the beginning, is worth it.

If you're ready to get started but wondering, *how in the world am I supposed to know which brush to buy with so many options?* the short answer is **Princeton Art Brush Co. series 4350 round size 2/0**. The long answer would be everyone has their own preference and I suggest trying out a few brushes to see what grooves with you. As I went through the process of experimenting, I noticed a few things that may help you out as well:

1) Some brushes have longer bristles which made them hard to control.

2) Some have really short bristles that I found didn't hold enough ink.

3) There are round, flat, and angled brushes. Each is great, but for lettering, I suggest sticking with round. The round tapered tip is what will help you achieve the thin and thick lines you are looking for.

4) Within the round category, there are varying sizes. For example, if you find a brand and brush you like, but plan to paint on a larger surface area, there is most likely a brush that looks the exact same, just bigger.

5) Don't be afraid of a small brush. Compare the strokes on page 99. The top one is made with a Tombow Dual Brush Pen, and the bottom one is made with a Princeton Art Brush Co. brush. They are very similar, right? From the outside, the size of the two tools is night and day, but when drawing, they produce similar end results. The little brush may be small in size, but it packs a punch.

6) Brushes are designed to work best with specific mediums—watercolor, acrylic, oil, mixed media, etc. That information can be found on the sales stand at art stores or, if you are shopping online, under the descriptions. This helped narrow down the brushes I experimented with, as I mainly letter with watercolor and ink. However, note that those are suggestions, not requirements.

7) I tend to use brushes that are made of synthetic hair. They hold the paint well, are easy to clean, and affordable. The Internet is your friend if you're looking for more information on the types of brush hairs.

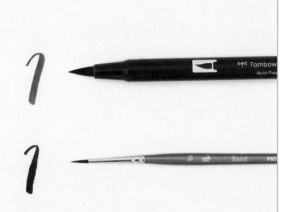

8) A note of caution: Any brushes you received as a freebie in a kit or the ones your kids paint with are most likely not what you should letter with. They tend to lack a tapered tip that, as we learned from section 1 of this book, is essential to achieving *thin on the up, thick on the down*. You can use them for other things, but I suggest lettering not be one of them.

Please know, I would rather you do these lessons with what you have or can buy than get held up on finding the perfect brush. Starting somewhere is better than not starting at all. I'll be lettering with the Princeton Art Brush Co. series 4350 round size 2/0 unless otherwise noted, but again, use what you have and what works best for you.

In addition, I'll be using **Strathmore 500 Series Marker Paper**, which works great with both ink and watercolors for practicing. This and the fact that it is translucent are why it's my favorite paper! For information on all other supplies check back to the tools of the trade section on page 12.

Let's dive in and continue learning the art of modern lettering.

11

BRUSH + INK

[PROJECT: **GIFT TAGS**]

Picture this: you walk into your next family holiday gathering with gifts wrapped, each adorned with hand-lettered tags. You will not only be walking in with a happy soul because you made these tags yourself, but I can imagine it won't be long before someone asks you, "Where did you get those tags? Those are so cool, I want some!" With a silly grin, you can eagerly reply that you made them and invite the relative to come over and make more anytime.

Remember when I challenged you on page 20 to push through the feeling and frustration of being a beginner? I explained that the moment you gave someone something you hand-lettered you would know why. This is the why. The pure joy you feel is something special because you created it. You were brave enough to put yourself out there and share something that you made by hand; it's a piece of you.

As we begin to letter with this new tool, if you find those same thoughts of frustration creeping up, remind yourself to keep on going. Your loved ones will enjoy anything you do because—let's be real—at the end of the day, this project will come with a present attached to it!

As you read in the brush introduction, there are several options to paint with when it comes to lettering with a brush. I suggest starting with ink because you can use it right out of the bottle. It doesn't require adding any water like we'll find with the other paints we'll look at. I'll be using Higgins Eternal ink, but there are many great inks out there. A few others can be found in the Resources section on page 262.

Let's start with the same warm-up strokes we did on page 19 of drawing little blades of grass. Take the lid off the ink bottle and dip the brush in the ink, letting it cover all the bristles. Then lift up, bring your brush to the paper, press down, and draw your blades of grass. Try this motion a few times and in different directions.

If you're trying to figure out how to hold the brush, grip it the same way you found most comfortable with your brush pen. It's less about your hand looking a certain way and more about you feeling in control. Feel free to flip back to page 17 to review.

Now let's practice. The same *thin on the up, thick on the down* that we used with the brush pen throughout section 1 applies here. Feel free to trace over my words to the right and use the arrows to guide you on direction. When your hand is moving up, use the tip of the brush and apply light pressure. When your hand is moving down, use the belly of the brush and apply heavier pressure.

thin on the up thick on the down

TROUBLESHOOTING TIP: *If you find your brush gets caught on the curves or the bristles flip when you don't want them to, remind yourself of what we learned with the foundation strokes in lesson 1. Think about the amount of pressure you are applying. Can you release pressure earlier or later to avoid forcing the brush into a certain direction? Guide the brush rather than pushing against it.*

to: from:

for you

with love

to: *to:* *to:*
from: *from:* *from:*

for you *for you* *for you*

Once you've practiced, let's take a look at what you have. Below are some troubleshooting tips to help you work through some problems you may be experiencing.

Do any of your strokes have a scratchy look to them?

- If your words look similar to *for you* above, you need more ink on the brush before you start lettering. How far are you dipping the bristles of the brush in the ink? If only the tip is getting ink on it, your brush will run dry sooner than if you submerge all of the bristles head to toe. It's okay if the ink gets on the brush handle. Dip the brush lower and draw the words again.

Does this ink look lighter in some areas and darker in others?

with love

- When you redip your brush and get more ink within the word, the first letter you draw may be darker than the others. This is because your brush is full of ink. Looking at *with love* here you can tell I redipped right before the *i* and the *o*. With this in mind, whenever you dip your brush again, draw a few strokes on scratch paper before you continue to draw the next letter. This will remove some of the initial ink that is causing certain letters to be so dark.

Are your strokes shaky?

You're learning a new tool; it's okay. Having shaky hands is normal, I promise. Here are a few things that may help:

1) Go back through lessons 1 and 2 for guided practice. Get to know this new tool and its tendencies.

2) If you find yourself drawing slowly and trying to make the line perfect, your hand will shake. On your next word, draw the stroke a little quicker. You can do it.

3) Try different ways to hold your brush. Find a grip that makes you feel comfortable and in control. Experiment. Look back at page 17 for other tips on this.

Gift Tags

with love

to:

from:

for you

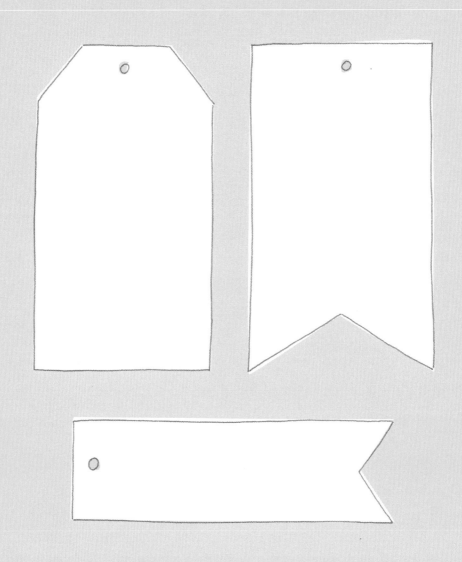

Project time! Gift tags to adorn your presents will make the recipient feel warm and fuzzy before even getting to the gift inside. Grab some cardstock, scissors, and a hole punch, or if you have premade blank tags from the store, go grab those and meet me back here.

SUPPLIES:

brush

india ink

pencil

cardstock

hole punch

scissors

light box (optional)

1) Trace the outline of the tags on page 106 to make your template. Then take your time and draw your words. This will be the same template you can use over and over again to make more tags in the future. If you need a review on connecting, revisit lessons 5 and 6.

2) Remember our handy tool the light box, which we first learned about in lesson 5? Use this again here or any other light source you have. Place cardstock over your pencil template to see the words underneath and lightly trace the tag outline with pencil. This will be where you cut in step 4.

3) Now dip your brush in ink and trace your words on the cardstock. Remember the troubleshooting tips you learned in this lesson and *thin on the up, thick on the down.* If you mess up, you can always make more tags!

4) After the tags are dry, cut along the outline, punch a hole at the top and you have your own handmade tags! Add to your gifts and walk into that next party with a silly grin on your face.

12

WATERCOLOR

[PROJECT: **CONFETTI CONES**]

Welcome to the world of watercolors. If you haven't met since kindergarten, nice to see you again. Let's think back to your days as a kid—when your favorite color was _____ , and you wanted everything in that color; when you were allowed to make a mess because you were just a kid and that's what kids do; when you thought everything was the best thing ever! It really was back then.

As we continue getting to know the brush and begin to explore the world of watercolors, I invite you to tap into that childlike mind-set. Watercolors come in every color of the rainbow, and if a set doesn't have your absolute favorite color, you can mix it yourself. This is your time to make a mess, and I highly encourage it. Embrace the imperfections. Be a kid, try something new, and throw around some confetti while you're at it!

You may be familiar with two different types of water-colors: those that come in a tube and those in a dry palette. In this book, we will be focusing on the dry palette; however, if you have tube watercolors and are familiar with them, by all means use what you are comfortable with.

Now, let's look at how to use them. Start with a jar of water next to you—nothing fancy, regular water will do the trick. Submerge your brush in the jar and bring over the water on your brush to the color of your choosing. For both tubes and the dry palette, in order to paint with watercolors, you must add water to create a liquid consistency that will flow from the brush. Think of this as giving the color some love

to "wake up." Continue with this back and forth of transferring water a few times to create a mini pool in the cake pod. Then dip your brush in the color and put your brush to paper.

As you paint your first few words, please know that it may not look exactly like you want it to. That's a-okay. There are a few troubleshooting tips below that may help you out as you continue practicing.

WHEN TO GET MORE COLOR

Similar to what we learned with ink, the watercolor will eventually run low on your brush, and you'll need to replenish. There isn't a magic number of how many letters you can get each time; however, you'll start to notice the color getting lighter if you

wait too long (art 1). In art 2, you can see the difference when you pick up color halfway through. Then, art 3 is an example of when you get color twice within the word.

You can also redip while still working on one letter. For example, the letter *B* here shows the comparison of getting color only at the beginning of the letter (art 4) vs. getting color a second time within the letter (art 5). You can see this B is a more solid color. There isn't a right or wrong way; it's up to you and the look you're going for. Keep experimenting and you'll learn as you go with how often to redip.

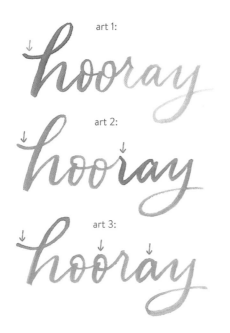

art 1:

art 2:

art 3:

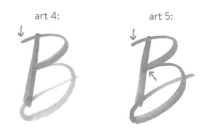

art 4:

art 5:

WHEN TO USE MORE WATER

The goal is to have a continuous flow of paint that glides off of the brush rather than the paint feeling stiff and getting stuck. If your strokes are similar to art 6 and have a scratchy, uneven look to them, that's a sign you need more water. Right now the paint is too thick and acting more like thicker acrylic paint than watercolor. Try two things.

1) Add more water to the watercolor palette.

2) And/or before picking up the color next time, dip your brush in your water first, then go to the palette and pick up the color and paint. Either way you'll want to make the paint more of a liquid consistency by adding more water.

art 6:

confetti

IF THE COLOR IS TOO LIGHT

Try dipping the entire brush in the color rather than just the tip. You might not be getting the full amount of color on your bristles and are therefore painting a lighter color. Angle your brush and twirl the belly around to pick up the color over the entire length of the brush similar to the photo on page 109. This way you make sure the full head of bristles is covered in color.

IF THE WATER SEEMS TO HAVE A MIND OF ITS OWN

Most likely you have too much water.

Before you write next time, hold your brush in the air facing down. If you see a little drop at the tip of your bristles, this is a sign you have too much water. That same drop will expand once your brush touches the paper. You'll also know you have too much water if the paint bubbles up and sits on top of the paper immediately after writing, rather than seeping into the paper. Adjust the next time you paint and experiment using less water.

Confetti Cones

Remember how I said in the beginning you'll learn by doing? This project is a perfect opportunity to make something fun, while still practicing. Watercolors are this perfectly imperfect paint that can be frustrating at times but also one of the most freeing and colorful things to paint with. At the end, you can fill these cones with whatever your heart desires and celebrate learning something new!

SUPPLIES:

brush

watercolors

water

watercolor paper or thick cardstock

scissors

double-sided tape

pencil

1) Trace the diamond shape template (page 114) on watercolor paper or thick cardstock and cut it out.

2) Instead of making a lettering template in pencil like we have been doing in past projects, I'd like you to just go for it and use your brush and watercolors. Paint your phrase one below the next and keep going even if you see a mistake. No one will be looking intently at the final product because they'll be enjoying what's inside! Continue to fill the entire diamond with your watercolor lettering. Let the kid inside you come out and play with all the colors in your palette.

3) If you're feeling fancy, wait until this side dries and then flip the paper over and do the other side.

4) Once your lettering is completely dry, if you have a blank side, have that facing up. If you filled both sides, then it doesn't matter which side you use for this step. Add a strip of double-sided tape to the bottom right side. Tuck the left side underneath the right and press the sides together to form the cone shape. It helps to fold from the bottom and create a point so the contents won't spill out.

5) Then fill your cone will confetti, dried flowers, or popcorn and enjoy at your next event or movie night! Hip hip hooray!

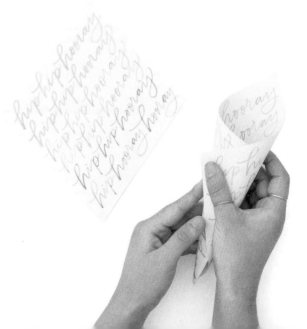

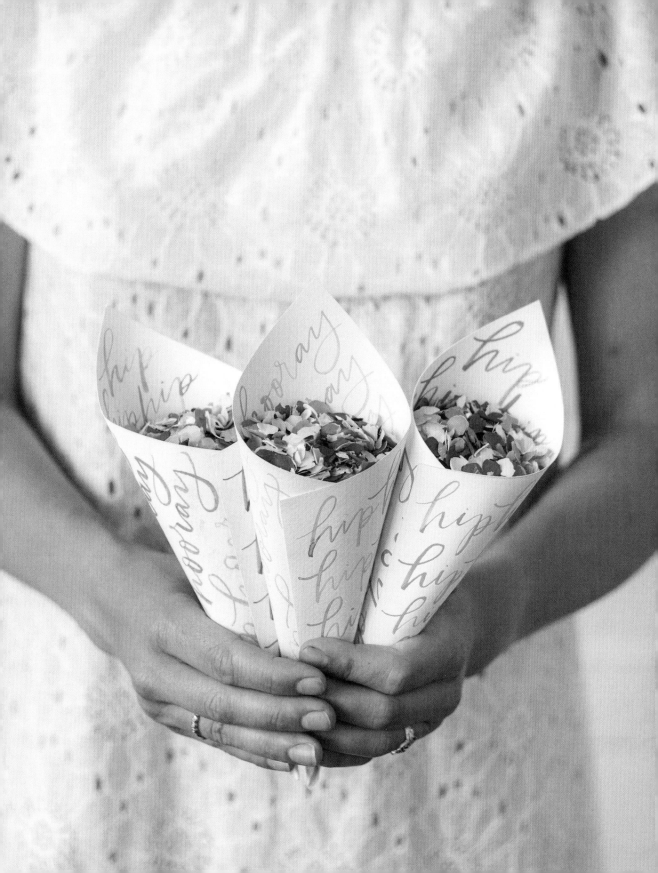

13

EXPLORING YOUR STYLE

+ bonus watercolor wash

[PROJECT: **PLACE CARDS**]

Think about the people in your life: the freebird hippie-at-heart, your sweet child-hood friend who has been there for you always, your adventure buddy who lives on the edge, the youngster in your life who teaches you all the "cool things." All of these people have their own personalities and unique characteristics—and the same can be said about your modern lettering.

Let's say you invite them all over for dinner and decide to make place cards to note where they will each be sitting. After going through this lesson, you'll have new lettering styles to use that also have their own personalities and unique char-acteristics. Not only will your friends feel special that you took the time to letter their names, but when it hits them that you chose a lettering style unique to them, they will immediately feel like royalty.

Adonis | Lizzy | Tracey

mmy | Vera | Debbie

Joe | Marla | Bart

iena | Bridget | Christina

Stephen | Evangeline | Kody

Kathy | Nathan | Anne

Misty | Dianuh | Lynn

Teri | Cassie

When I first started lettering, I had only one look. I would write the same exact way every single time because that's just the way I wrote. So I understand if you felt the same way at the start of this book. However, going through all of these lessons together, my hope is that you are already seeing this doesn't have to be the case. You now have several ways to change up your "handwriting" from altering the spacing in lesson 7, playing with the angles in lesson 9, and being aware of the shapes of your letters in lesson 10. Let's put those lessons to use.

Below is the word *beautiful* written four different ways, each in its own style of modern lettering. If there is one version you gravitate toward, use the scale to the right to see the breakdown of why. For example, the first *beautiful* looks the way it does because the spacing is *wide*, the angle is *slanted*, and the shape is *oval*. The second example looks different than the first because the spacing is *medium*, the angle is *straight*, and the shape is *oval*. By changing just the spacing and the angle, this word has been given a whole new look.

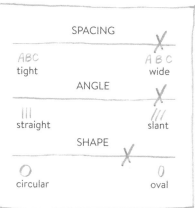

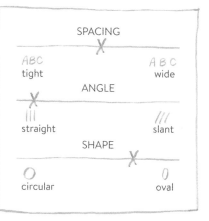

beautiful —

SPACING

X		
ABC		A B C
tight		wide

ANGLE

X

| ||| | | /// |
|---|---|---|
| straight | | slant |

SHAPE

		X
O		O
circular		oval

beautiful —

SPACING

X

ABC		A B C
tight		wide

ANGLE

X

| ||| | | /// |
|---|---|---|
| straight | | slant |

SHAPE

X

O		O
circular		oval

Now, think about your friends and their personalities. Practice writing their names and move along the spectrum of any or all three of the scales: spacing, angle, and shape. You'll be surprised at how different your lettering will look by altering even just one of them!

BONUS LESSON: WATERCOLOR WASH

There is another way you can add some personality to your lettering, and it doesn't even involve thinking about the letters. It's called *making a mess and playing with water-color washes*. If you have a larger brush or a flat wide brush similar to the one used in the instructional images here, take those out for this project. Then grab some watercolor paper, your watercolors, a cup of water, and a paper towel. Either have scratch paper underneath or do this project on a surface area where it is okay to get a little messy.

To make the wash, dip your entire brush in water, pick up your color from your palette and then paint directly on the paper using any of the following techniques.

1) Sweep the brush back and forth until it fills the area desired.

2) Paint in circular motions using the belly of the brush, either starting from one end and moving to the other or starting in the center and moving out to the edges.

3) Start with painting just water on the paper. Then add your color and watch it move.

4) Use your hand as a tool and bring back finger painting from when you were a kid.

Note that doing a full watercolor wash may cause the paper to warp, curl, and feel thinner than when you first started. This is normal. You can decrease the amount of curling by either using thicker paper or less water. I used 140 lb. watercolor paper in these examples for reference.

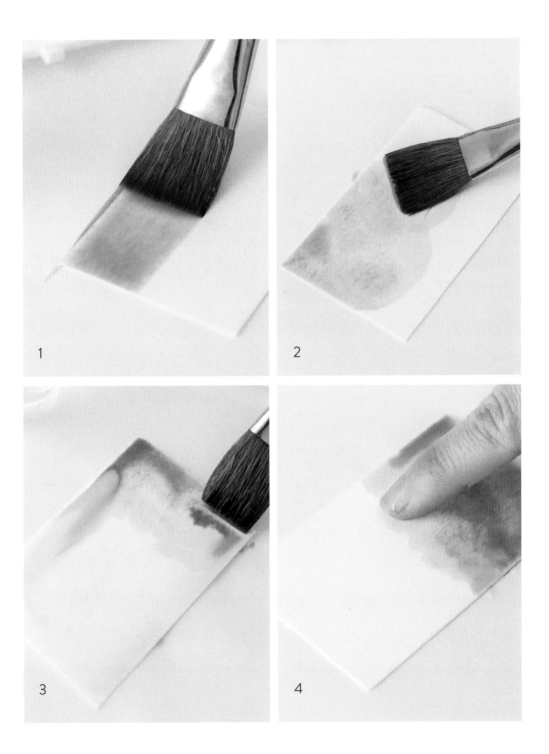

Place Cards

Lizzie

Joe

Siena

Kody

Bridget

Let's combine both parts of our lesson. Your friends names in different styles + the watercolor wash = place cards that will make others stop and ask who made them!

SUPPLIES:

brush for lettering

wide brush for the watercolor wash

watercolors

water

watercolor paper

scissors

paper towels

1) Cut watercolor paper to the size of your liking. Mine are 3.5 x 1.75 inches.

2) Paint the watercolor wash with the technique that worked best for you from the list of options in the lesson. Use a lighter color as you'll be adding the lettering on top of it. Experiment with painting just the center of the card, the full card, or the corner.

3) Let the paper dry for at least 30 minutes. If you add your lettering too soon, the new watercolor will bleed.

4) Once your wash is completely dry, you are ready to letter. Either make yourself a template of the names written out on a separate paper and use a light box to trace them onto the cardstock or skip that step and draw directly on the place card with your brush and watercolors. Review lesson 12 for tips on how to do watercolor lettering.

5) If the ends of your cards are curling, when everything is dry place them beneath a handful of books or anything heavy and press the paper overnight. This will help flatten the paper.

6) Finally, set the table and put the place cards at each setting. Sit back and watch your friends' faces light up as they see what you made them!

tip

If you'd like to create a wash that goes from light to dark, first paint the color as you normally would. Then simply use water and paint away from the initial color you laid down. If you'd like the beginning area to be more saturated in color, go back and add more color to the edges. This will create a gradation effect.

Beauty in Imperfection

Yes, watercolors can be frustrating. You're still figuring out how much water to use and how to get the colors even. It may feel like you are painting differently every time. I get it: there's a lot of factors involved. But there is also a lot of beauty and a lot of freedom in letting go of control and allowing the paint to move, breathe, and do its thing. It's a reminder that we are all unique and no two are the same. There's an organic fluidity and something perfectly imperfect about it. Those human imperfections are what make you you, and they are what make modern lettering modern lettering. It's unique and personal and different every time.

So is life. Maybe we don't need to have everything fully planned out, and certain things don't need to happen the way we planned. If they all did, our life would look like a computer font. Everything would be the exact same every time, and it wouldn't be our own story.

What you are doing here is creating something out of nothing, using your own two hands (well maybe just one unless you're ambidextrous) and letting the authentic you shine. That is what people want: to feel the human connection, to see the human imperfections, to have a piece of the personal infused in their life because we are all human and we all have imperfections. Find the beauty in the imperfections and embrace them.

14

THUMBNAIL
SKETCHES

[PROJECT: I HEART YOU CARD]

When you walk into a gift store and see the wall of cards in front of you, your eyes either light up with excitement at all the options or you turn the other direction because of all the options. Either way, you have probably noticed the same words and phrases used season after season: happy birthday, thank you, congrats, happy holidays, and the list goes on. Yet even with these same phrases, there are new cards for you to choose from year after year.

It's time to think of yourself as the designer of those cards. You are tasked to see how many possible ways you can write those three little words: I love you. There is no such thing as saying it too many times and also no such thing as drawing it too many times. So where would you start . . . ? Although your answer might be to Google it, I'll bet your next move would be to grab a pen and paper and get your ideas down. This is thumbnail sketching.

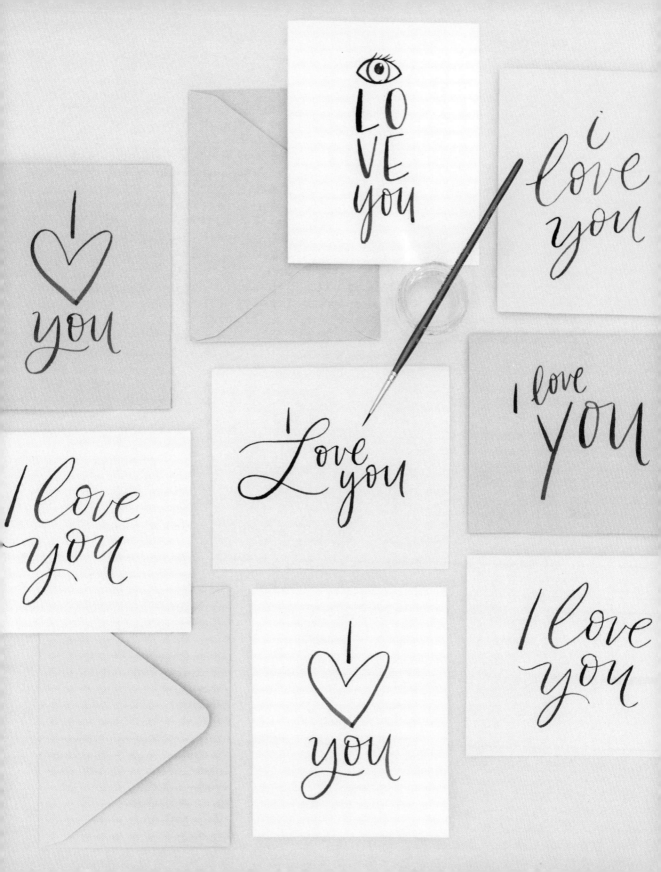

Although not a literal term, think of thumbnail sketches as little doodles. They are rough drawings to get the ideas out of your brain and onto paper. This is the time to experiment, try different styles, different layouts, combine ideas, and start to envision what your final product may look like.

Let's do this exercise: see how many ways you can write the phrase *I love you*. Try stacking the words, drawing them on a diagonal, or sketching them on a curve, making *you* bigger or *love* bigger. There is no wrong sketch and this is all for you—no one else needs to see this initial stage. Maybe you like one of the sketches and want to explore that one more. Play with the lettering style,

change the angle (lesson 9) or make the letters more circular than oval (lesson 10).

If it helps, set a timer—let's say five to ten minutes. Think of all the possible layout options for this phrase or a different short phrase and work through your ideas. Keep in mind that the focus isn't on thin and thick lines or making the letters perfect. Your ideas are meant to be rough. There isn't a certain number of sketches you are trying to hit, and even if your first thumbnail sketch feels like the winner, do a few more just to see what other ideas you come up with. You never know what else you have up your sleeve!

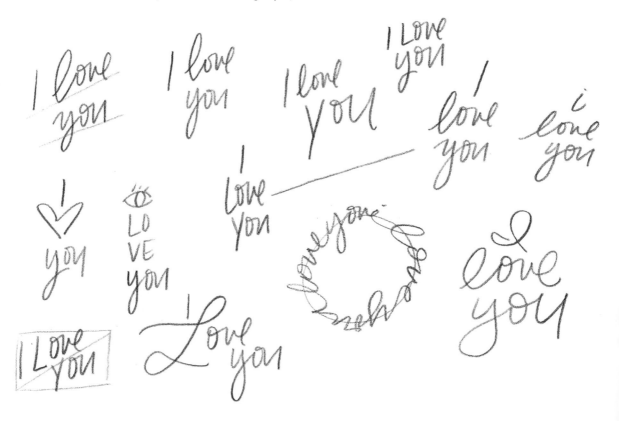

I Heart You Card

Is there a person in your life you've been meaning to send a card to? A special some-one you want to remind how much you care? Now is the perfect time. You've gone through designing the look of the card in this lesson and now it's time to execute.

SUPPLIES:

brush

watercolors or ink

water

cardstock

pencil

eraser

light box (optional)

scratch paper

scissors

1) Either buy prefolded cards from a craft store or make your own. I like to use size A2: 4.25 x 5.5-inch for cards. To make your own, cut watercolor paper or cardstock to 9 x 5.5-inch and then fold it in half.

2) To help visualize what the final card will look like, have your thumbnail sketches out and draw a rectangle around the final one you wish to make bigger. For this example, the card is vertical as seen on page 129.

3) Make your to-scale template. To do this, on another piece of scratch paper trace the outline of the card. Then using your thumbnail sketches as a reference, draw any guidelines for yourself in pencil. Since my design is written at a diagonal, I drew similar diagonal lines for my template on page 131.

4) Draw the design bigger on your to-scale template. By doing step 2 and having a rectangle around your sketch, you will be able to visualize how big to draw this to-scale template in relation to the frame, i.e., the card.

5) Now it's time to paint. We've taken the time to learn both ink and watercolors, so feel free to use either one in this and the lessons to follow. With a light box underneath, open up your card and tape it over your template so you can see your sketch through the card. Trace over your design and focus on drawing stroke by stroke: *thin on the up, thick on the down.* Lesson 11 or 12 is there for a refresher on ink and watercolors.

6) Once your lettering is dry, add a message to the inside, place in an envelope, and send off to a loved one just because. Be proud that you just made a sweet handmade card! And you can use your to-scale template from step 4 to make more anytime. Spread the love.

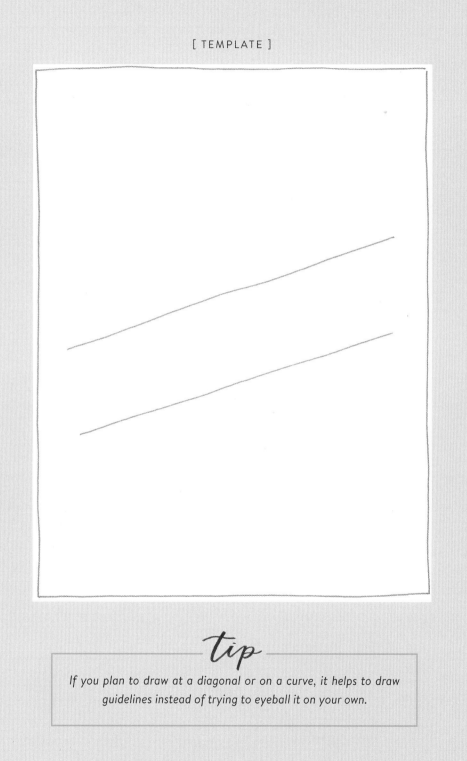

tip

If you plan to draw at a diagonal or on a curve, it helps to draw guidelines instead of trying to eyeball it on your own.

15

FLOURISHES

[PROJECT: HOME SWEET HOME SIGN]

What do you do to make your home feel you? Do you have photos hanging up on your walls? Are souvenirs from your travels tucked in shelves among stacks of your favorite books? Do you have a green thumb, or are like me and wish you had a green thumb, to be able to bring a little piece of Mother Nature indoors?

As you've been learning, there are things you can do to make your modern lettering you as well. It is not just writing letters—just like your home is not just the four walls around you. You add things to it. And in this lesson, the addition comes in the form of loops and swirls, aka flourishes. We'll learn when and where to add flourishes and create a wooden sign to hang in your home for another addition that will make those walls feel even more like you.

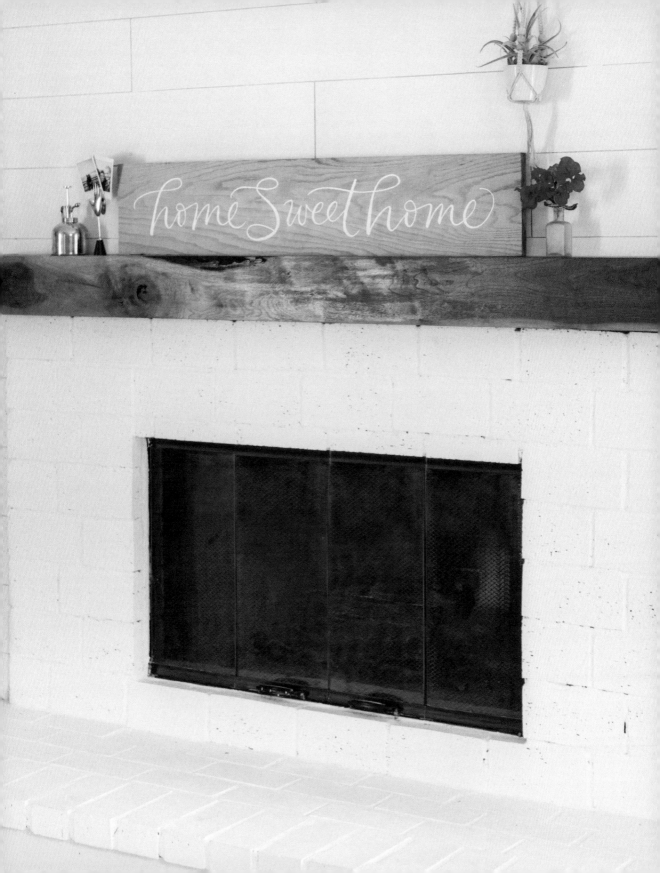

Flourishes are swoops and loops, curls and twists. Think of flourishes as extensions of your strokes and the accessories to your letters. They add to your foundation and bring out the beauty of your letters, but they don't overpower and steal the show.

Start by practicing the flourishes by themselves. Trace over the strokes below and warm up your hand. Either draw the flourishes using your whole arm moving with the stroke, or keep your hand grounded and move just your fingers. Find which technique works best for you, then practice these strokes bigger.

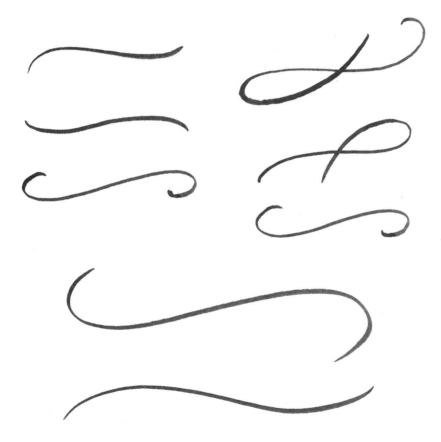

WHEN AND WHERE TO ADD FLOURISHES

Flourishes can be used as little or as often as you'd like. More doesn't necessarily mean better. Flourishes can be large or small, dramatic or subtle. Some designers are able to incorporate big loops and curves and make them look effortless. I am not one of those people, so it's okay if you're not quite sure how to do that either. Start small. Think of them as adding a curve to your strokes.

Here's an example. When you cross a *t*, instead of drawing just a straight line, make it a curved stroke and curl the ends.

together together

Or add a similar curve to the beginning of a word.

we we

A curve can also be added to the tall letters with an additional loop flowing seamlessly like we learned in lesson 5.

bloom bloom

Use these examples as small ways to incorporate flourishes in to your own designs without it feeling too overwhelming.

Now let's walk through an example of the process:

1) Start with your phrase and circle points where you can add a flourish. In addition to the suggestions we've already looked at, flourishes can be tacked on to the end of a word as well.

art 1:

home sweet home

home sweet home

2) Then add a curve or loop to those points.

art 2:

home sweet home

3) Are there any negative spaces around your words you can fill with a flourish to balance the design? Try extending the flourishes you've already started or making the loops bigger to take up the open areas. (art 3)

art 3:

home sweet home

home sweet home

4) To refine your design a step further, look for shapes and strokes you can mimic. Flourishes feel effortless when they are similar to the letters themselves. Think of them as following the lead of the letters and extensions of what is already created. In the example below, I liked the curve of the *t* and chose to change the curve of the *h* flourish to mimic that. I also made the tail on the *e* smaller to have a similar ending curve. In addition, there was open space above the *s* that I chose to fill with a different style letter, and I added the same curve to the beginning of that letter as well. Now that feels complete!

art 4:

home sweet home

home sweet home

As you can see with these steps, we went from art 1 to art 4, and those little flourishes add character to the design. They are purposeful, and the final lettering flows. Try the steps above with your own phrase and see where you can add some flourishes.

art 1:

home sweet home

art 4:

home sweet home

tip

Find a font on the computer that has flourishes, and use that as inspiration. See what additions are made to those letters and how you can put similar ones on your own.

Home Sweet Home Sign

If you didn't notice by now, this is our first time together lettering on something other than paper. Wood is a great surface to start with and can be purchased precut at a craft store or, if you're looking for a specific size, a home improvement store is your best bet. They have small and big pieces you can request to be cut to a certain size. The wood I'll be lettering on for this project is 36 x 8 inches for reference.

SUPPLIES:

larger round brush

white opaque ink

wood

chalk

brush for mixing

pencil

paper towel

clear matte fixative

1) Sketch. Go through your thumbnail sketch phase like we learned in lesson 14 and plan out your design. Try adding flourishes and see how that works with the letters and space you're working with. Once you have finalized your design, keep your sketch out for reference.

2) Draw your design. Although you can use a pencil like we've been using, another handy tool that I like to use is chalk. I suggest doing this first before going straight to painting with the brush. This way you can make mistakes and easily erase with a paper towel.

3) Refine. This is the time to make sure you're happy with your design. Take a step back and look at what you have. Do you see any spots you can fill in with a flourish? Does your lettering feel balanced?

4) Supplies. We've been painting with ink and watercolors up to this point; however neither will work when painting on wood. Both of those mediums will seep into the wood and won't show up. The answer is a thicker paint and, for this project specifically, a thicker white paint. Unfortunately the white on your watercolor palette will not suffice. Insert my favorite white—Dr. Ph. Martin's Bleedproof White. This paint is opaque and flows off the brush nicely without getting stuck and hindering the stroke from flowing.

Similar to watercolors, though, we have to add water in order to use it. Using the end of your brush, scoop out a penny size amount of paint and add a few drops of water. I like to use the lid or a separate palette for this. Mix the paint and water together and test it out on scratch paper. You'll want a smooth consistency without it being too watery and transparent when you paint on the wood. Reference the Resources section for a few other great white paints to try out.

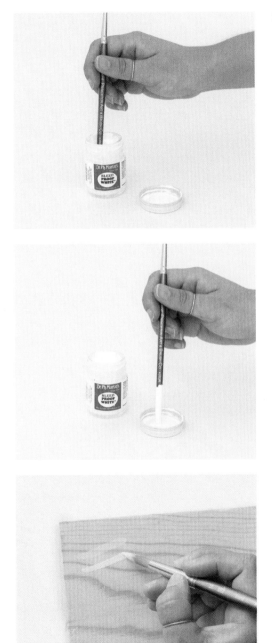

5) Painting tool. This is also our first time together painting something larger. Remember on page 98 when I mentioned that there are bigger round brushes? Now is the perfect time to use one of those. Paint the same way you do with a smaller brush, but be mindful of how much pressure you need to apply in order to get the thin and thick lines. For example, because the brush is bigger, you might not need to press as hard as you do with a smaller brush to achieve a thick downstroke. Use the back of your sign to practice. Then flip back over to the front and paint over the chalk design you made in steps 2 and 3.

6) Once your lettering is completely dry, use a dry paper towel to rub off any of the chalk you can still see. Do not use a damp paper towel as the paint will smudge if it gets wet. However, this is a great trick if you make a mistake: you can rub it away with a damp paper towel!

7) If you plan to hang your sign outside or you anticipate it being in contact with water (even a humidifier in your home), seal your work with a clear matte fixative. This can also be purchased at a home improvement store.

8) Hang your new sign on your front door or over your fireplace and cozy up in your home sweet home.

16

THE BOUNCE
+ bonus block lettering

[PROJECT: **PARTY INVITE**]

Congrats on graduating! Congrats on getting the job! Congrats on your new home! It is fair to say we as humans love to celebrate. It's not only a reason to party, but it's also a moment to recognize all that we have been through. These are the times when we put our hands in the air and say, "I made it! I made it through." Getting to this point probably wasn't smooth sailing. We all know that life throws you curveballs and it's a lot of hard work to get to the point when others can celebrate with you. Personally, I can say those ups and downs are what have shaped me into who I am today. And maybe you feel the same way too: the highs and lows, laughter and tears, add up to make you you.

As we continue to develop your lettering style, let's embrace the ups and downs of your words as well. There is no one telling you to follow a straight line or that your letters need to be a certain size. I encourage you to explore and allow those highs and lows to be what they are. In this lesson, we'll learn how to add a bounce to your letters and make a party invitation for you to send out to your loved ones. Have a craft night with your friends and invite them over to learn with you. There's always a reason to celebrate!

When it comes to crafting the style of your letters, we've learned how to play with the angle (lesson 9), the space between the letters (lesson 7), and, from the previous lesson, how to add in flourishes (lesson 15).

art 1:

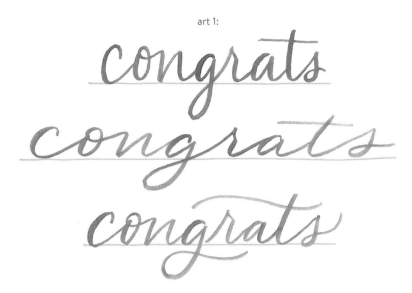

All of the sample words above, despite looking different, have one thing in common: they all follow a straight baseline—the invisible line that the letters sit on.

art 2:

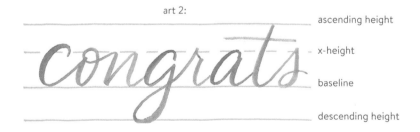

ascending height

x-height

baseline

descending height

In school, you might have been taught something similar to art 2. The **ascending height** is where tall letters and capital letters should stop. The **x-height** is the height at which your small letters should stop. The **baseline** is the straight line all the letters should sit on. And the **descending height** is the opposite of the ascending height, where the letters that extend below the baseline should end.

Did you catch the common word, *should*?

Yes, this is the structure that allows us to be able to read each other's handwriting, and I do believe it is important to know these rules and remember what we were taught growing up. However, with modern lettering take this *should* lightly.

Let's look at more sample art. Art 3 is *congrats* following a straight baseline and art 4 and 5 are *congrats* written with a bounce. Here's the breakdown of how it's done:

Art 4: The *n* and *t* dip below the baseline, and the *g* sits above it. In addition, the small

letters do not all hit the same x-height. You can see this with the *n* and *a* especially, which are shorter than the other letters.

Art 5: This word has more of an exaggerated difference in the size of the letters. The *o* is smaller and floats above the baseline. The *r* has an exaggerated loop and extends above the x-height. The *a* is also smaller but sits on the baseline. And the *s* is bigger and extending below the baseline.

These changes to the letters are what create the "bounce" and flow of the word.

art 3:

congrats

art 4:

congrats

art 5:

congrats

So how do you go about adding bounce to your own lettering?

1) Play with where your letters sit—extend them above and below the baseline.

2) Play with scale—make some letters smaller, some bigger, and/or exaggerate the loops.

3) Add a dramatic bounce, mix things up, create a rhythm, and—most of all—keep a balance. If you start to find your word has too many ups and downs, take a look at where you can balance it out. For example, after trying to add the bounce to *congrats* in art 6, the word appears to be floating away on a diagonal. If this happens to you, draw yourself a baseline. Although we've discussed that all the letters do not have to sit on the baseline, it is a good home base to reference back to. If we bring down just the *t* and *s*, art 7 is now back on track and doesn't look like it's leaning over anymore, while still having the bounce to it.

art 6:

congrats

art 7:

congrats

tip

*Whether you are trying to add bounce to your word or create more cohesion with your letters like we learned in the first section of this book, remember this: **practice with a purpose.** You can practice your letters over and over and you can write the same word over and over, but at the end of the day, they may still look the same. Yes, muscle memory is important and practice does make perfect; however, I believe it is just as important to practice with a purpose. Take some marker paper and overlay it on top of your word. Try extending one of the letters below the baseline. Try making one of the letters smaller. Then take a step back and look at what you've created. Do you like it? Are there other areas you can try something different? Do you need to make other adjustments to balance the change you just tried out? Experiment, evaluate, and then keep on trying. Practice with a purpose.*

Party Invite

Before we can have the party, we have to send the invites out. And before we send the invites out, we have to actually make the invites! Let's do this together.

SUPPLIES:

brush

watercolors

water

watercolor paper or cardstock

a wide brush

washi tape

scratch paper

pencil

scissors

light box

pen

1) Cut either watercolor paper or cardstock to the size of your invite. The template on page 149 is 5 x 7 inches, which will fit in an A7 envelope (5.25 x 7.25 inches) if you plan to mail these out. If you decide to add a watercolor wash for a fun burst of color, use watercolor paper. Add the wash first using the techniques we learned in lesson 13 and allow time for the wash to dry.

From experience I suggest making a few more pieces than the number of guests you plan to ask. It is easier to make more at this step than to get to the end and have to repeat!

2) Make your template. Draw a 5 x 7-inch rectangle on scratch paper and draw out five lines. These will be your "fill in the blank" for the event information. To space out your lines evenly, it may be helpful to use grid paper (page 257) like we did in lesson 9 with the menus. Then in the area at the top, sketch out the word or phrase you'd like to use for the big announcement - *let's party!*, *you're invited*, *let's celebrate!* If you haven't figured out your lettering design yet, pause and work on that now. Think about this lesson and try to add some bounce to your letters.

BONUS LESSON:
BLOCK LETTERING

Did you know that the lessons we've learned throughout this book can also apply to your block print style. Change up the angle, spread out the spacing, make the letters tall and oval or wide and circular. Write out the words *who*, *what*, *when*, *where*, and *RSVP* to add below each line on the template.

3) Check if your watercolor wash is dry. If it's not, always wait it out. The lettering will bleed if the paper is still wet. Once that's completely dry, have your light box out and tape the cardstock on top of your template with washi tape. If you can't see your pencil sketch, go over it with a dark pen to make it darker and easier to see through the water-color paper.

4) Now it's time to do the watercolor lettering. Pick your color, add water to your palette (reference lesson 12 for the full watercolor lesson), and then paint away. *Thin on the up, thick on the down.*

5) Repeat. Repeat. Repeat. You want to invite all of your friends and family!

6) With a regular pen—or if you're feeling fancy, continue with your brush—fill in the blanks with your party info, and then mail out the invites. The following lesson will be on envelope addressing so you can go through that next and add lettering to the envelope as well. Party time!

WHO *who* WHO WHO WHO

tip

When writing small, especially with block letters, use just the tip of the brush and apply light pressure. You'll notice that you can lightly graze the paper and still paint the letter.

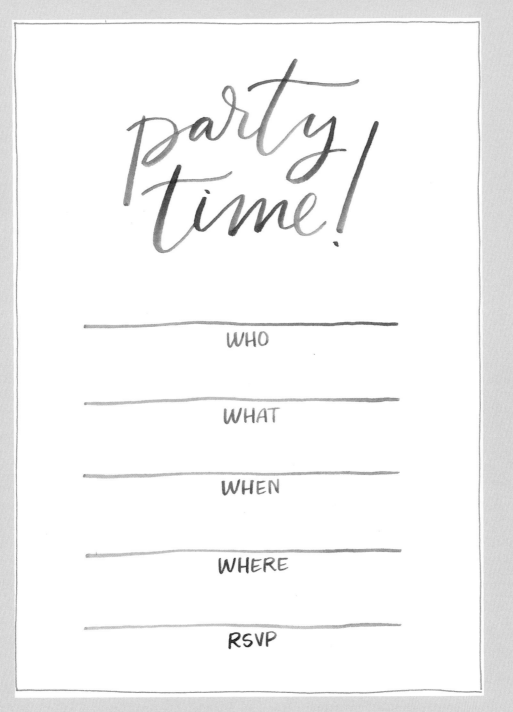

WHO

WHAT

WHEN

WHERE

RSVP

17

EXPLORING LAYOUTS

[PROJECT: ENVELOPES]

When was the last time you mailed a physical card? I'm not talking about sending an e-mail or a text message—a card with an envelope that you addressed, put a stamp on, and slipped in the mailbox? If it's been too long for you to remember, time to change that here. Mail a card to a friend you haven't talked to in a while, who had suddenly crossed your mind. Or write a sweet note to your grandma, who you know would love anything from you. Or make a card thanking someone who recently did you a huge favor. Receiving an envelope in the mail that isn't a bill is always a treat—even more so when it's beautifully hand-lettered by the sender. It feels like opening a present. And if you're engaged and have a wedding or special event coming up, this lesson is perfect for you too. Congrats to you!

Stephanie and Eric Walker
217 Coral Boulevard
Honolulu, Hawaii 96710

Shannon David Lyn
321 First Avenue #2
New York, NY 10001

anni + Nick Connors
121 PINE BOULEVARD #1
SEATTLE, WASHINGTON 98101

Sydney + Kyle Trigg
517 Alderwood Drive #8A
Orange, California
9 2 8 6

KINDLY DELIVER TO:
Rick + Lori Bright
418 Lemon Ave.
San Jose, CA 95120

Britt & Brian G
622 West Washington
Atlanta, Geo
3 0 3

Before starting with your brush, let's talk about the layout and make a plan of action. Envelope addressing consists of the name, street, city, state, and zip code.

FORMAT

Typically addresses are written on three lines:

NAME
STREET
CITY, STATE ZIP CODE

However, we can also move the zip code to the bottom and have four lines:

NAME
STREET
CITY, STATE
ZIP CODE

LAYOUT

Decide if you'd like the address centered, left justified, or on a diagonal.

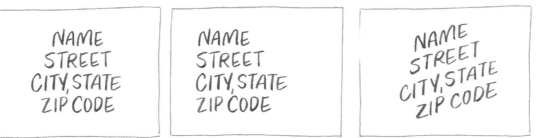

DESIGN

There are several options for you to play with for the design. For the purpose of this book, I'm going with the format of four centered lines. I'll also be using the same address in these examples to the right so you can see the slight differences. Then you can pick and choose what works best for you!

Christy · Gary Winston
5996 Culver Boulevard
Los Angeles, California
90012

Christy · Gary Winston
5996 Culver Boulevard
Los Angeles, California
9 0 0 1 2

For the zip code, the numbers can be written together in the center or spread out.

Christy · Gary Winston
5996 Culver Boulevard
Los Angeles, CA
90012

Christy + Gary Winston
5996 Culver Boulevard
Los Angeles, California
90012

The state can be abbreviated
or fully spelled out.

The names can be bigger
than the address.

Christy + Gary Winston
5996 CULVER BOULEVARD
LOS ANGELES, CALIFORNIA
90012

Christy & Gary Winston
5996 CULVER BOULEVARD
LOS ANGELES, CALIFORNIA
90012

Try the address in a block font
(lesson 16) to make the names stand out.

Experiment using the word *and* or
an ampersand sign instead of a plus sign.

Envelopes

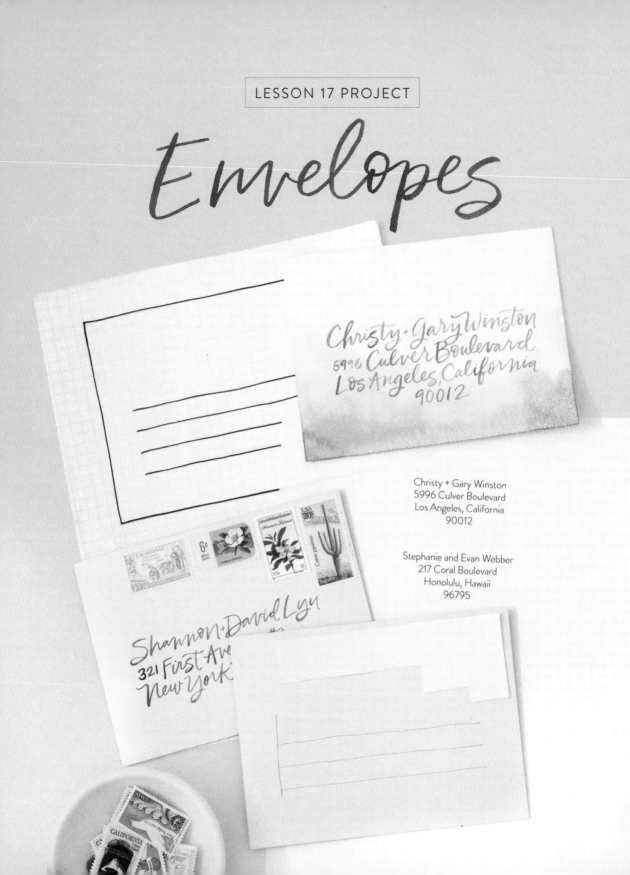

Christy + Gary Winston
5996 Culver Boulevard
Los Angeles, California
90012

Stephanie and Evan Webber
217 Coral Boulevard
Honolulu, Hawaii
96795

Now that you have your layout planned, it's time to execute! Below are a few tips to help you along the way.

Also know that there are several different sizes and shapes you can choose from. A few are shown in the image on page 151: rectangle, square, long, and skinny.

SUPPLIES:

brush

india ink

watercolors

white opaque ink

pencil

ruler

eraser

envelopes

light box (optional)

How to draw straight

- Use a pencil and ruler to draw faint lines on the envelope as your guidelines, and then write the address on those lines with a brush and ink. Wait a few hours to erase the lines. You don't want to smudge the beautiful address you just made!

- If your address is left justified, draw a vertical line in pencil to know where to start each line.

- The light box is a handy tool here as well. Instead of drawing the grid lines on the envelope itself, make a template on grid paper like the image to the left. Then place that underneath your envelope on the light box so you can see the lines through your envelope paper. This will be your reference every time. However if your envelope is too dark, this option will not work.

- Some other great tools are the Slider Writer and the Lettermate.

How to keep it all centered (or at least aim to)

This is the hardest part of writing addresses. I wish I had a foolproof trick for you, but this is just something that will improve with practice. I'm still working on it myself, and it will always be a work in progress.

- My first tip is to have extra envelopes.

- In addition, if you have a computer, type the address in a document and center it. This way you have a rough idea of how much room each line will take up and how they relate to each other.

- To center the zip code, draw the center number first and then follow with the other numbers to the left and right. If you're drawing the zip code spread out, write the first and last numbers first. Then find the center and draw the third number. Finally draw the second and fourth number in the spaces between.

Deciding which medium to use

- You have options. The same black ink we used in lesson 11 also comes in various colors. Then you have watercolors from lesson 12 and the newest addition, white paint from lesson 15 that you can use on dark colored envelopes. My suggestion to you is to test the envelope out before addressing your first one. If you find your ink is bleeding into the paper or bubbling up and not staying, try a different paint. Often this will happen with shimmer envelopes or coated papers. We'll also learn about another medium, gouache, in the next lesson, which is an option if any of the scenarios above occur.

How to write the small addresses

- Use a small brush! Remember how I said the Princeton Art Brush Co. series 4350 round size 2/0 is my favorite? This is one of the many reasons why. You can use the same brush to write the small addresses and create very thin lines while still achieving the thin/thick variance. Focus on using the tip of the brush and press lightly. You'll be surprised at how lightly you can graze the paper and still write the letter. This will be especially helpful if you are writing in a block font.

Postage

- Double-check the amount. Ask yourself, "What size is this envelope and will a forever stamp be enough to mail?" If you have any hesitation, I highly recommend going to the post office to confirm how much postage you need. The amount of postage increases with square or larger envelopes, additional weight, or if there's anything inside that pops up preventing the envelope from laying flat. Also international addresses always need more!

- For stamps, good ol' USPS has some, or if you're looking to customize, there are various online sites. A few are listed in the Resources section of this book. If you have a photo or a logo, this is a perfect opportunity to add that to the outer envelope.

- Vintage stamps can also be found online as well from various stamp collectors. Yes, they exist! Make sure the stamp is still usable as you might find a very cool vintage stamp that doesn't mean anything to the mail carrier. Keep those for your personal collection.

Jazz it up.

- Add *Kindly Deliver To* at the top of each address. These can either be in your lettering or in a block font. It's a nice touch.

- Add a watercolor wash like we learned about in lesson 13. Just make sure the wash is dry before you start your lettering. The Luxe line of envelopes from Paper Source is a great textured, thick envelope for adding a watercolor wash.

- Add splatter dots by either using a bigger brush or a toothbrush. For a bigger brush, dip all of the bristles in the ink and tap it with another brush over the envelope. This will get the paint to drop off of the big brush. Or for a toothbrush, run your fingers across the bristles toward the paper. I suggest doing this before writing the address just in case you get a big paint drop that covers up any part of it.

As you continue addressing, remember each time is going to be something different. You'll have a new set of letters and numbers to play with. Explore different layouts and designs, and keep in mind that it doesn't need to be perfect (just legible for the nice postal worker). If you are addressing a bunch of these for an event, remember that they are all going to different homes. No one will be holding two together comparing, so it is a-okay if they aren't the same!

Be a Problem Solver

If it hasn't happened already, once your friends and family find out you're giving this whole lettering thing a try—even if it is just for fun—someone is bound to ask you to letter on something. And that something may come in the form of shiny ribbon, tiny pieces of sea glass, or a surface you didn't even know could be written on. First of all, how cool is it that someone wants you to letter for them? Big high five! Second, the story can go one of two ways: A) You panic and respectfully decline. You've never done something like this before, and you have no idea how to make it happen. B) You say yes and you figure it out.

You may be sitting there reading this wanting to be person B, but most likely you're person A. It's okay: I'm usually that girl too. But this lettering journey has taught me to be person B. Be a problem solver. I don't claim to know everything, and you certainly don't need to either. Every tool is different, every surface is different, and every circumstance is unique. Maybe the pen you thought would work just won't stay on the surface, or you have to write on seashells, ship them all the way across the country, and avoid having them scratch each other during transportation. Be a problem solver.

You will be put in situations you don't have all the answers to, and there will be moments that completely throw you off guard when panic overrides any bit of good ol' common sense. That's life. But if you're willing to give it a try, ask questions, and put your thinking cap on, you can figure it out. You may be surprised what opens for you when you're willing to push through. And don't forget, once upon a time you wanted to try this whole lettering thing out. You didn't know how, so you bought this book, went through these lessons and projects, and now you are here. Well, guess what? That makes you a problem solver already. Life lesson learned. Now go be person B.

18

THIN VS. THICK

[PROJECT: **RIBBON**]

You bought the gifts, wrapped each one of them nicely, and everything is ready to go for the family party. As you check one more time to make sure you have all of the gifts for each person, you feel like something is missing . . . What is it? It then dawns on you that you made ribbons to go with each present and you were waiting for the paint to dry in the other room! You go grab the ribbons, tie them around each present, and smile—now it all feels complete.

The same goes for your lettering. When you write the word, it is all there. The letters, the connecting strokes, the thin and thick lines. It all looks great, but you might feel like something is missing—just like how the ribbon was missing on the present. With one tiny addition in the form of a thick downstroke, your word can look that much more complete. In this lesson, we'll learn how to train your eye to pinpoint what may be making your word feel off and how to fix it with one simple stroke.

birthday

congratulations congratula

happy b

made with love

love made with

First, take out any words you've written with the brush up to this point. Remember our mantra: *thin on the up, thick on the down*? Take a look at your words and see if you are following that. Not sure when the stroke should be thicker and when it should be thinner? Put your brush down and simply move your hand along the strokes you made. Say to yourself, *thin on the up, thick on the down, thin on the up, thick on the down* as your hand moves in that direction. This will help you focus solely on the movement of your hand and note what size the stroke should be.

Now looking back at your own words, are your thin lines similar in size to each other? Likewise are all of your thick lines similar in size to each other?

Let's compare the two words here as an example. All of the thick downstrokes in art 1 are not the same size. Look closely at the *t, d,* and *a.* These strokes are thin, but if we are following our tagline *thin on the up, thick on the down,* those strokes should be thicker. Now look at art 2. Can you see the difference? Those three strokes on the *t, d,* and *a* are all thicker now and consistent with the rest of the word. Now the word feels more unified.

art 1:

art 2:

As you continue on this lettering journey, you'll begin to train your eye to see that even though the letters are all different, the strokes that make them up should be similar and consistent to each other. For example, an *a* and *d.* If you look at *made* in art 3, the curve of the *a* is thick and yet the curve of the *d* is thin. Similarly, the downstroke of the a is thin and yet the downstroke of the *d* is thick. After noticing this, instead of starting over simply add a thicker stroke to those lines that should be thick. This will make the word look more cohesive like in art 4.

art 3: *made* art 4: *made*

Now as much as this lesson is to help you see thin and thick, what if we wrote a word with only thin strokes or all thick strokes? This is breaking the guidelines but also following them, as all the thins are consistent in art 5 and all of the thicks are consistent in art 6. Although I've been hammering home the concept of *thin on the up, thick on the down*, you can also write *thin on the up, thin on the down* or *thick on the up, thick on the down*. This is another way to craft your style and match the lettering to the occasion or material you're writing on. For example the all-thin style pairs nicely with the delicate ribbon for this project. You can choose.

art 5: *made with love*

art 6: *made with love*

Note that each of these examples is made with the same brush (Princeton Art Brush Co. round size 2/0). This just reinforces how much variation in stroke size you can get with one brush.

tip

TROUBLESHOOTING TIP: *If your word feels off and you've gone through the other troubleshooting tips of checking the angle and the spacing, take a look at your thins and thicks and make sure those are consistent as well. Remember they can be all thin or thick as well! They just need to be consistent.*

Ribbon

Ribbon is a nice added touch that can complete your present, or serve as the decor item that brings it all together at your event. The beautiful silk ribbon you see here is made by Tono + co and comes in all different colors.

SUPPLIES:

brush

gouache: gold, black, white,
or any color your heart desires

small jar or paint palette

ribbon

scratch paper

scissors

1) Sketch and plan what you're going to letter. If it helps, trace the outline of the ribbon on your scratch paper and make yourself a template. Sketch your letters within that area and try a few different styles out. Try doing all thin strokes or all thick strokes from this lesson and see what you like.

2) Ribbon is made of up tiny pieces that, when threaded together, create tiny holes. Therefore if you try to write on ribbon with ink, watercolors, or brush pens like we've been using in past projects, you'll find that it bleeds and feathers out in these tiny holes. We need a thicker paint that sits on top of the ribbon instead of seeping into it. Another option to Dr. Ph Martins' Bleedproof White that we used in project 15 is a new paint to introduce you to called gouache. **Gouache** is an opaque water-based paint that comes in tube form. And guess what . . . it comes in gold *and* so many other colors that you can mix together to make your own color.

To prepare the paint, squeeze a pea-size dollop of the gouache either into a small jar or on your paint palette. I prefer to use a small jar so I can store the color and continue to reuse it after a project is complete. Then add a few drops of water to mix together. Start with less water than you think you'll need; you can always add more. It is recommend to use distilled water, but tap water has always been fine for

me. As you mix it all together, create a consistency that is thicker than india ink, but doesn't get stuck on the brush when you paint. This requires trial and error to get the right thickness, so have a scratch paper out to experiment on.

3) Test the gouache. Paint a few practice strokes on any extra scraps of ribbon to make sure you have the right consistency. If your ink is bleeding, add more gouache. If it feels chunky or doesn't glide smoothly off of your brush, add more water.

4) Go for it. As you paint stroke by stroke, you may notice that your brush will run out of gouache fairly quick. This is normal. Since ribbon is a porous material, it will soak up the ink faster than paper, requiring you to get paint sooner and more often.

5) Once your lettering is dry, add the ribbon to your presents, wrap around a flower bouquet, or simply wave them in the air because you just wrote on ribbon!

6) Bonus idea: Go back to the foundation strokes and make some wrapping paper to go with your ribbon. You can paint on darker paper with gouache in gold, white, or any color to add a fun pop!

19

GRADIENT COLORS

[PROJECT: **WALL ART**]

One of my favorite things to do is watch the sunset: sitting there, surrounded by nature, mesmerized by the colors of the sky changing right before your eyes. It gets me every time. The way they gradually blend without my being able to pinpoint where one color stops and one color ends is something truly special.

You too can create this same feeling with your own lettering.

In this lesson we'll learn how to blend watercolors and create wall art to enjoy in your home . . . just like the sunset that is happening in your corner of the world every single day.

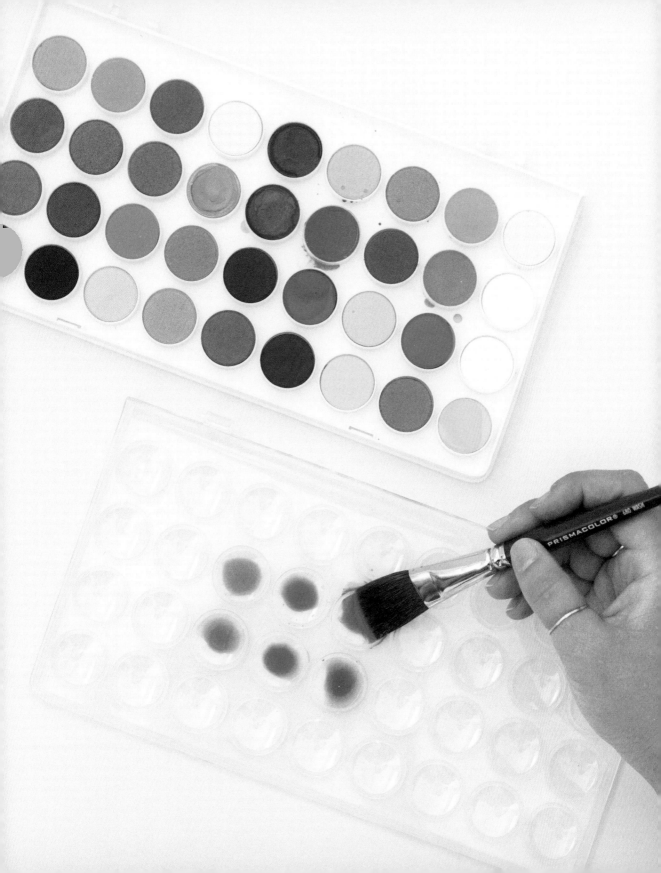

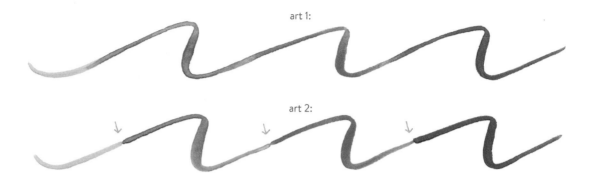

art 1:

art 2:

What's a gradient? It's a fluid change from one color to another and when created with watercolors is a winning design. Start with any color and begin to paint the first stroke as you usually would. Then pick up the second color and while the original stroke is still wet, overlap the second color at the tail end of the first and continue on with the stroke.

The trick is in the overlap. When you overlap a part of each color, the two are able to blend together and create a smooth transition (art 1).

When you start the second color right where the first color ends, the tails don't have the opportunity to blend together, creating a sharper transition and one where you can tell exactly where the new color started (art 2).

art 3:

rise

art 4:

rise

When you overlap and blend the connecting colors, your eye sees one continuous stroke (art 3) rather than two segments (art 4). Think of it as the second color grabbing the first color's hand, shaking it, and then bringing it along for the ride as the two continue forward. Give it a try.

CAN I GO FROM LIGHT TO DARK OR DARK TO LIGHT?
CAN I USE ANY COLORS?

It's totally up to you, and there are no rules either way. However, if you start to blend two colors and find it becomes a tad muddy or brown (art 5), your eye may be going directly to that point of connection rather than seeing one blended stroke. Try a different color next time (art 6). The idea of a gradient, like the sunset, is that you can't tell where one color stops and one color begins. If it helps, think of the rainbow: red, orange, yellow, green, blue, purple. Pick a color that is close in that family.

If your color palette doesn't have the exact color you want, mix it up yourself. I like to use the lid of my palette and bring over a few colors as seen on page 167. If you're painting a large area or plan to use this color often, mix a healthy amount at once so you won't have to remake it again if you run out.

art 5:

and

art 6:

and

WHEN DO I PICK UP THE NEXT COLOR?

You get to decide. Maybe the entire word only consists of two colors (art 7 and 8), so you pick up the second color in the middle. Or maybe you want to mix four colors (art 9), so you pick up the next color every few letters. Either way, remember to overlap. You can choose to overlap the color at the beginning of a stroke, or within a stroke. Compare art 7 and art 8. In art 7, the second color started at the top of the *n* stroke, and in art 8, the second color started between the *i* and the *n*. Both are great options for you to play with.

art 7:

shine

art 8:

shine

art 9:

shine

art 10:

art 11:

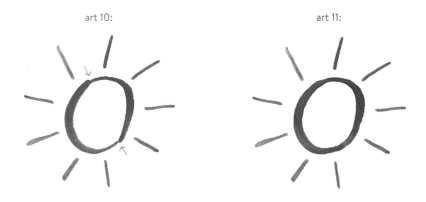

AM I ABLE TO FIX ANYTHING I DON'T LIKE?

One of the beautiful things about watercolors is that this medium is very forgiving. It's not set in stone once you paint the color. Let's say your letters are dry and you find there's one transition that isn't as smooth as you'd like it to be (art 10). With a clean brush with a little bit of water on it, gently rub back and forth over the connection point that you don't like. I like to call this "reawakening." You'll notice the colors start to move again, and you can now smooth out the transition or add a little bit of color if you find it too light. Try not to go overboard and I don't suggest doing this often. But it's a fun little trick if you're in need of a quick fix. And no, art 11 was not altered in Photoshop.

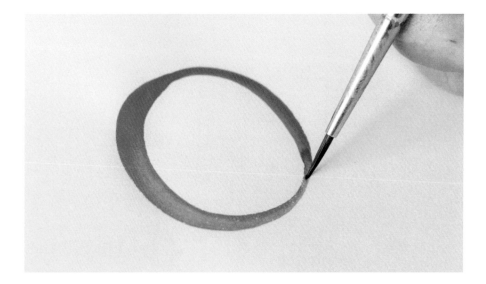

Wall Art

Now that you've added gradient lettering to your wheelhouse of things you can do, let's get more practice in. The best way to get comfortable blending is to learn by doing. The color may blend too far into the previous color or it can come out a different shade than you anticipated. Remember this is the nature of watercolors, especially when blending. Take note of its habits, keep experimenting and go back and read the life lesson on Beauty in Imperfection on page 124. Have fun with it, and let's make some art to add sunshine to your walls.

SUPPLIES:

brush

watercolors

water

watercolor paper

pencil

scratch paper

dark brush pen

light box (optional)

washi tape

scissors

frames

1) Cut a few pieces of watercolor paper to the size of your frames.

2) Using all the skills you've learned, try designing a quote on your own. Draw thumbnail sketches (lesson 14) and make a larger template of your final design. With a dark brush pen, draw over your pencil sketch making the thin and thick lines. This way when you paint in the next step, you'll know when to make the stroke thin vs. thick and you can focus solely on blending the colors. Feel free to trace the 5 x 7-inch design here to practice as well.

3) Using a light box, tape the watercolor paper over your template so you can see through to it. If you have an idea of the colors you plan to use, add water to those colors on the paint palette and then paint away. Experiment with color combinations, try going dark to light or light to dark. See what blending two colors looks like vs. four colors and try different places to make the overlap. If your final piece is larger, you can use a bigger size brush similar to one we used in lesson 15. Use the same techniques.

4) Bonus: Using the watercolor wash techniques from lesson 13, experiment making gradient washes and overlapping the colors. Once your washes are dry, either do the lettering in watercolors or use gold gouache like we learned in lesson 18. Have fun and make more to send to your friends!

rise and shine

20

THE PROCESS

[PROJECT: **LINEN BANNER**]

There is a reason most of these lessons start with a pencil. Although it's not used to make the final piece, the pencil is a tool that can help you get there. It is part of the process. It's your friend that will carry you from one step to the next without feeling overwhelmed, from getting the ideas out of your head onto paper with your thumbnail sketches to making your sketch larger for your to-scale template. The pencil plays a role and one that will become even clearer in this lesson.

What happens if you want to make something bigger? You may be looking at the banner here and thinking, "How did she make that so big?" or "Wow, I wish I could do that!" Well, you can! In this lesson, we will break down the steps and show you the process of how to get from an idea to a final product. Once you've completed this project, you'll have your own banner to hang up loud and proud.

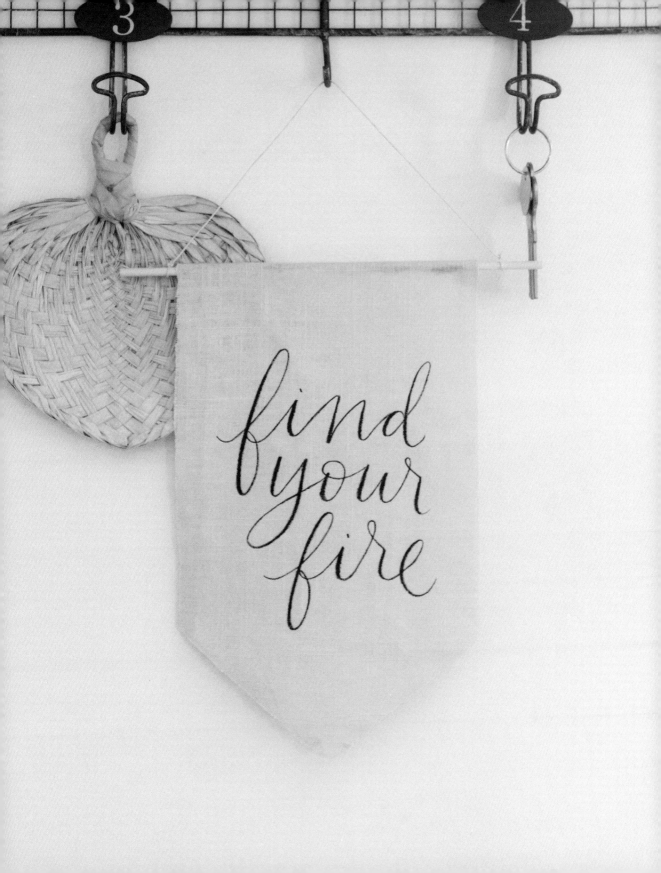

Linen Banner

It's time to unveil the process, what goes on behind the scenes. Let's walk through the steps from concept to final product. Feel free to follow along with your own quote or find your fire that I'll be working with.

SUPPLIES:

pencil

grid paper

scratch paper

brush

black gouache

linen or canvas

1 dowel

painter's tape

light box (optional)

E6000 clear permanent adhesive

scissors

string

dark pen

Make thumbnail sketches

In lesson 14, we learned that thumbnail sketches are rough doodles to get all your ideas worked out on paper. Start with a pencil and some scratch paper and experiment (art 1). Here are a few prompts to get your brain going:

- try stacking the words
- open up the space between (lesson 7)
- change the angle (lesson 9)
- alter the shape (lesson 10)
- add flourishes (lesson 15)
- test out block fonts (lesson 16)

Refine sketches

Once you've drawn your thumbnail sketches and picked the one you like, take it a step further and refine that sketch (art 2). In this stage, really look at the strokes and see if there are any little additions or alterations you can make to complete the design. I explored playing with the ends of the *y* and *f* and also tried making *your* smaller in relation to the other words. These sketches will be more precise than the first attempts.

art 1:

find your fire
find your fire
find your fire

find your fire
✱ find your fire
find your fire

find your fire
find your fire

art 2:

find your fire
find your fire
find your fire

find your fire
find your fire

Make the to-scale template

Unless you are drawing a tiny banner the size of your pencil sketch, this step will get you from small to big. For some people, including myself, it doesn't come naturally to draw something really big. Having to draw a design proportionally on an 8.5 x 11-inch piece of computer paper is daunting. Here's what to do.

1) First draw a rectangle around your final thumbnail sketch similar to what we did in lesson 14 (art 3). This is a mini version of what your banner will look like. Then break this sketch into four sections by drawing a vertical line and horizontal line through the center over your sketch.

art 3:

2) Take out a piece of computer paper and fold it in half both ways to use for your to-scale template. This will create the same four sections as your thumbnail sketch. Think of these four sections as four mini drawings. Deal with one quadrant at a time and sketch proportionally what you see in your thumbnail sketch onto the larger template. Focus on drawing lines, rather than the letters.

If you find yourself focusing on the whole piece rather than a specific quadrant, flip your thumbnail sketch upside down. This way you are drawing just what you see and not writing the letters themselves. It's actually a fun exercise and a good way to train your brain.

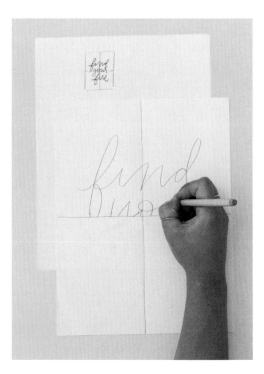

3) Continue drawing quadrant by quadrant.

4) Once you have all four quadrants fin-ished, take a step back. Do you see the letters now? Hopefully the answer is yes! Feel free to refine in this stage and fix any areas that may need to be adjusted.

5) When you are happy with your tem-plate, use a darker pen and go over your sketch. This will help you see through the linen when we paint our banners.

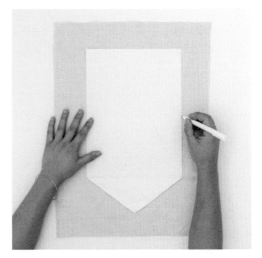

Prepare the final product

The final banner we're making is 8.5 x 11 inches, plus a little longer for the triangle point at the bottom. To make a template for the linen shape, I have a trick for you. Grab another piece of computer paper and a piece of grid paper. To make the triangle point, use the grid paper to find the middle a few squares down (the number will depend on how sharp you want the point to be), and draw a dot there. Use a ruler and make a line connecting the dot to both corners of the paper. This guarantees a symmetrical trian-gle rather than just eyeballing it and hoping it is even. Cut along those lines and tape the triangle to the bottom of the computer paper. Now you have your banner template. To make a sturdier one, trace this computer paper template over a piece of cardboard and cut that out.

With either template, outline the shape on your linen or canvas and cut this out using scissors. For this project, I suggest using fabric that is thinner and a lighter color. This way you can see your template through the fabric with a light source. Before you throw out the scraps of fabric, test out your paint. Use gouache, as it won't bleed as much as ink or watercolors. See lesson 18 for details on how to mix gouache.

Paint

Now it's time for the part we've all been waiting for: painting. If you don't have a large enough light box, this is when your window and sunshine come in handy. My roommate thought it was funny every time she would walk in and see my art projects taped to the window. It's okay, that can be you too. First tape your paper template to the window using painters or masking tape. Then decide where to tape the linen based

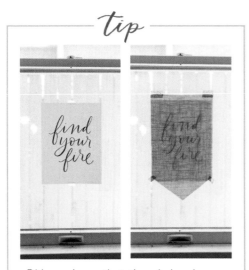

Did you know that the window in your home can be used to make this banner? Use it during the day with sun shining through as your light box to see your template through the fabric.

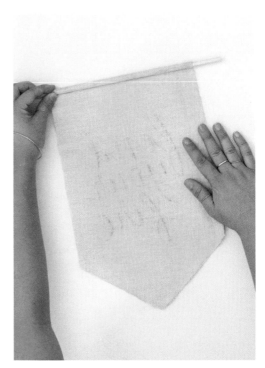

on where you want the quote to be positioned on the banner.

Now you are ready to rock and roll. Have your brush and gouache in hand and paint the lines as you see them through the linen. I'm still using the small Princeton Art Brush Co. brush, but if you'd like thicker lines, use a larger brush. Working with fabric is similar to ribbon in that you will need to go over the letter a few times to fill it in. If you find that the ink is bleeding or feathering out, add more gouache. You'll want the consistency to be smooth and flow off the brush, but not so watery that it bleeds.

Final touches

Once the paint is fully dry, lay the banner facedown and add a strip of adhesive bond glue to the top. Then place the wood dowel on the glue and hold it there until it sets. Wrap some of the fabric around so the dowel is covered. I can't sew, but if you can, another option is to sew a pocket for the dowel to sit in. I, on the other hand, will be over here gluing away.

If you're worried about the edges of the fabric fraying, there's a handy tool called Dritz Fray Check with an applicator tip that you can use to seal the edges. Then cut string the length of your liking, tie to both sides of the dowel, and hang up your banner loud and proud!

BRUSHES:
IN A NUTSHELL

REMINDERS

- Use any combination of angle, spacing, and shapes to create new styles (lesson 13).

- Take it in steps, starting with thumbnail sketches (lessons 14 and 20).

- Practice with a purpose (lesson 16).

- Add bounce by ignoring the straight baseline (lesson 16).

- *Thin on the up, thick on the down* or all thin or all thick (lesson 18).

- Overlap colors when creating a gradient look (lesson 19).

- Use a window as a big light box for larger projects (lesson 20).

TOOLS

- The round small brush—small tapered tips can still achieve both the thin and thick strokes (intro to brush section).

- The large round brush—use for bigger projects (lesson 15).

- The wide flat brush—use to make watercolor washes (lesson 13).

- Ink can be used right out of the bottle (lesson 11). Watercolors (lesson 12), white opaque paint (lesson 15), and gouache (lesson 18) need water for a smooth stroke.

- The pencil is your friend (lesson 20).

- Marker paper—slightly transparent paper is great to overlay as you build your words out.

- A light box—allows you to see through thicker cardstock.

- Chalk—functions like a pencil when designing on wood (lesson 15).

TROUBLESHOOTING TIPS

- If your word feels off and you've tried out the other troubleshooting tips for the angle and spacing, look at your thin and thick lines and make sure those are consistent.

THE LIFE OF BRUSHES

- Just like your own hair, there may be a few bristles that do their own thing and don't want to cooperate. That little hair will eventually get annoying and show up in your lettering as a small line that follows you around. When I buy brushes, I always purchase a few extras.

- Knowing that bristles are sensitive, don't leave your brush facedown in your ink, water, or when storing them. The weight of gravity will curve them over time, and this will affect the tip.

- When you are cleaning your brushes, also don't smush the brush down. I suggest rolling the bristles in a wet paper towel at an angle to get the paint off.

LIFE LESSON

Be kind to yourself

I can imagine you're sitting here reading this and feeling a little overwhelmed. Maybe you're having thoughts like "Why am I not picking this up faster?" or "Why doesn't mine look like hers?" or "I'm just not good enough."

On this lettering journey, I've come to know that voice trying to fool me into believing that I'm not good enough as well. And as I've taught both in-person and online workshops, many students have shared that they have similar thoughts. You are not alone.

"WHY AM I NOT PICKING THIS UP FASTER?"

Everyone—and I mean everyone—is a beginner when they start out. Take a look at the first piece you did in the beginning and then look at the piece you just wrote before I asked you to pause. I bet you've already improved from when you first opened this book. And if that doesn't satisfy you, here's another way to look at it—the fact that you still have some journeying to do is something that is pretty darn cool. When you do get to hit those aha moments and feel that accomplishment, those sensations of excitement, joy, and pure bliss are something to cherish. Who doesn't love those sweet moments in life?

"WHY DOESN'T MINE LOOK LIKE HERS?"

The comparison game is real. It's easy to get caught in the hustle and bustle of what everyone else is doing. You may catch yourself scrolling through your social media feed comparing, wishing, and wanting something that someone else has. But remember what I mentioned in the beginning of the book on page 20: everyone has their own signature. You have your own voice, your own vision, and no one else is like you. You have journeyed on your own path that has led you right here to this moment, and you have a story to tell. Let your unique story shine through in your letters.

"I'M JUST NOT GOOD ENOUGH."

Those thoughts of inadequacy or "not having enough of" create fear and self-doubt that can leave us paralyzed and wanting to stay where we are because it's more comfortable. Please, please, please try not to feed into this. Not sharing yourself with the world is not helping anyone and most definitely not helping you. Know that this is a journey and a daily practice, not a one-and-done click of your fingers. Spread a little joy today, and let's all try and be a little kinder to ourselves.

Pens

If the brush pens weren't your thing and the brush felt like a little too much at the moment, that's a-okay. You have your foundation set, you're discovering your style, and in this final section, you'll be learning new ways to refine your lettering style, all while adding a few new tools to round out your toolbox—the pens.

The pen world ranges from ballpoint pens to paint pens to gel pens to pens made for specific surfaces, like chalk pens, fabric pens, ceramic pens, and many more. They are different than the brush pens we used in section 1 and don't have a brush-like tip that bends with pressure. However, you can still achieve the same beautiful modern lettering with delicate thin upstrokes and bold thick downstrokes. The difference is that these are created in a second step and not during your lettering. There will be more to come on this in the following lessons.

When I'm not using a pencil, I'm using **Micron pens by Sakura of America.** This is the pen I highly recommend for practicing and doing your sketches. They come in several sizes, many colors, and write smoothly.

For the projects, we'll be using paint pens. Paint pens are the reason you can write on pretty much any surface. Brush pens, most inks, and watercolors either seep into the material or don't adhere at all. Remember lesson 18 with the ribbon? That's why we used gouache: it's essentially a thick opaque paint. But for these projects instead of painting with a brush and paint, we'll be using a paint pen. A few of my favorite brands are **Molotow, Sakura Pentouch, and DecoColor Paint Markers.** They come in various sizes and colors including white, and the Sakura Pentouch brand is my favorite for metallics. Paint pens do require a little more love than standard pens, so let's look at how to get them started.

1） Before opening, shake the pen. Think of it as a can of spray paint. There is a tiny ball inside that mixes the paint when you shake it. Keep it going for about thirty seconds.

2） Open the cap. You'll find a bare tip that is either white or an off-white color. On scratch paper, push down on the tip so it disappears back into the pen. Hold this for a few seconds and then release. With some brands, you'll start to see the ink flow through the tip immediately, while others you may need to press down one or two more times. However, avoid pushing down too many times and overpumping.

3） Once the paint is fully covering the tip, test it out. Use the paint pen like a regular pen and draw.

4） When you are done, put the cap back on and store with your other pens. Know that the next time you go to use it, you may need to reshake it to get the paint flowing and press down on the tip one or two times. Do this on scratch paper as it might explode with paint from sitting for so long. And as a disclaimer: my paint pens do dry out and I often buy new ones.

I'll be using the pens mentioned here and introducing a few others, but don't forget there are other options and I highly suggest trying them out on your own to see what is the best fit for you.

21

HOW TO
FAKE IT

[PROJECT: NOTES, CALENDARS, TO-DO LISTS]

Do me a favor, take the pen out of your purse or the one sitting on your desk. Yes, that one. Did you know you can create modern lettering with the same ballpoint pen you use to write notes with? And better yet, did you know you can practice this lettering style while you're on the phone with your mom, or at the airport eagerly awaiting your next destination, or at a restaurant waiting for your check to come? All you need is a pen, something to write on (even a sticky note, a napkin, or the back of a receipt), and the knowledge in your brain of everything you've learned thus far.

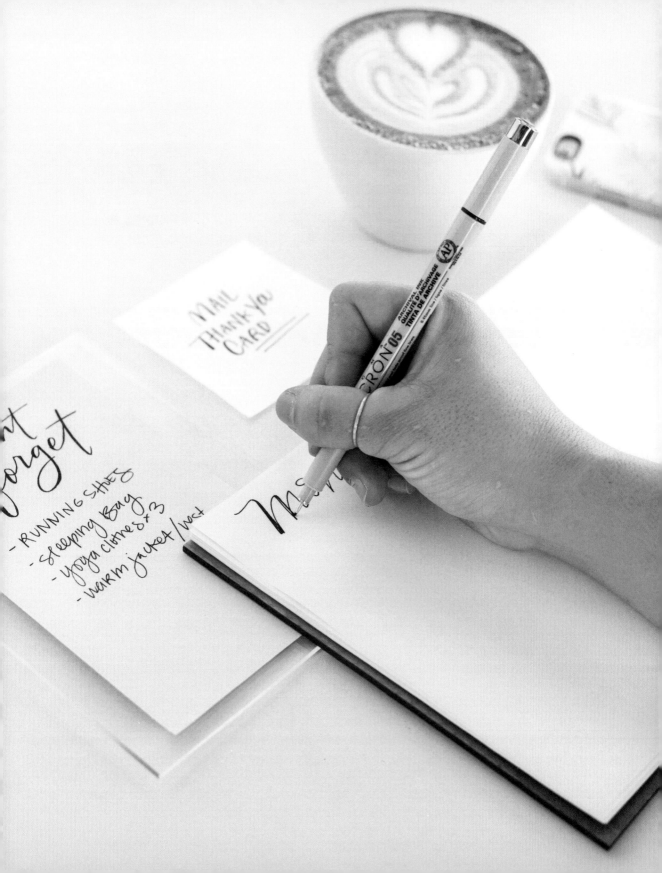

As I mentioned in the pen intro, modern lettering doesn't require a brush pen or a brush that bends to create the thin and thick strokes. You can "fake" the look with a regular pen using the steps below.

The How-To

1) Start with your word written out. If you're looking for a refresher on how to connect your letters, review lessons 5 and 6.

art 1:

2) Figure out which strokes need to be thicker. *Thin on the up, thick on the down.* When your hand is moving up, leave the stroke as is. When your hand is moving down, make a mental note of that stroke for step 3. The arrows in art 2 show those parts.

art 2:

3) Draw a line next to those strokes you noted in step 2 when your hand was going down. Leave some space and connect that added line back to the original stroke (art 3).

art 3:

4) Fill in the space between the line you added and the original stroke so it appears as one fluid downstroke.

art 4:

5) Kick back, relax, and enjoy—you did it!

tip

TROUBLESHOOTING TIP: *As you continue on your own, a good test is to write the same word with a brush or brush pen (art 5) and then go through steps 1–5 here with the pen. This way, you can see if the thick strokes you added (art 6) are the same or similar to the strokes created with the brush.*

art 5:

art 6:

art 7:

today
t

art 8:

today
t

When you are adding the line for the thick stroke, the goal is to create a smooth transition from thick to thin. Think of how you use the brush to apply heavy pressure on the downstroke—as you near the bottom, you gradually release pressure for the thin upstroke. The key is making the transition *gradual*. To do this, mimic the original stroke you're adding to, and avoid simply drawing a straight line.

If you compare the two words in art 7 and 8, you'll see the slight difference. Looking at the *t* in art 7, the thick downstroke added is a straight line, creating a harsh connection near the bottom. But in art 8, the thick downstroke is added as a curved line, creating a curved and tapering connection. This is more fluid. The same thing is happening with the *y* in this word.

Now if you're wondering how to make your thin lines thinner, unfortunately the pens aren't like the brush where you can apply less pressure to create a thinner stroke. However, you can always use a thinner pen. Micron pens by Sakura of America come in various sizes as shown below and are great, not only because of how small they come, but for how smoothly they write.

As a side note, I'd like to point out that this technique does *not* replace everything we've learned together thus far. Think of this faux calligraphy, as you may hear it called, as another tool in your toolbox. It's adding on to your letters in the styles you've been crafting and creating in all of our earlier lessons. We'll use this technique in the projects to follow as we continue to refine your lettering style and focus on the letters themselves.

Market list

Market list

Market list

MICRON 01 ARCHIVAL INK QUALITÉ D'ARCHIVAGE TINTA DE ARCHIVE

MICRON 05 ARCHIVAL INK QUALITÉ D'ARCHIVAGE TINTA DE ARCHIVE

MICRON 08 ARCHIVAL INK QUALITÉ D'ARCHIVAGE TINTA DE ARCHIVE

Notes, Calendars, To-Do Lists

Now it's time for you to practice! This project is for you to simply use this technique in your everyday life. The next time you jot down a reminder on a sticky note, write out your grocery list, or add to your planner for the week, go through steps 1–5 from this lesson. Modern lettering doesn't only have to be for special occasions. Bring it into your life at this very moment.

SUPPLIES:

any pen within your reach

any paper within your reach

1) Using a pen, write out your word.

2) Figure out which strokes should be thicker. *Thin on the up, thick on the down.*

3) Add a line next to those strokes from step 2.

4) Fill in the space between.

5) Look at you go! You're creating this beautiful hand lettering style with an everyday pen. Keep going and have fun!

22

THE TOUGH CONNECTIONS

[PROJECT: **PLACE MATS**]

Somehow the day flew by—workout in the morning, meetings, coffee run, lunch with a friend, happy hour with a coworker, and then kids' soccer practice. Oh and can't forget to bake cookies for the party on Sunday. All of a sudden the day is gone, it's time for bed again, and you realize you didn't even eat dinner. Any of this sound familiar? At some point, sitting down with family and friends at the dinner table may have been put on the back burner amid our go-go lives. Conversations happen more on our phones than they do over a meal, and I'm sure most of us can agree it's not something we're too proud of.

It's time to make a change.

What if we pick a date and invite friends and family over for dinner—even if it's just the immediate family? What if we set aside time to be together, away from our to-do list, our work, our phones—and to just be? And when everyone arrives to see his or her name on a placemat at the table, it's bound to start the meal off on the right foot. Plus, your guests never have to know you made the mats twenty minutes before they walked in the door. That's our little secret.

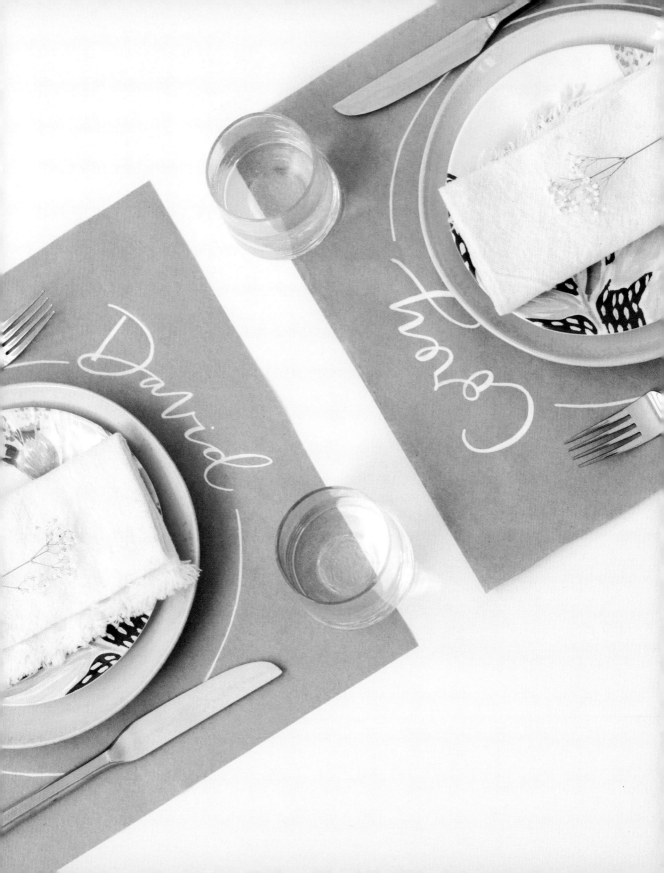

No matter the tool you are using, when writing your words out, you may find some tough connections that don't seem to flow as seamlessly as others. Have there been times you weren't quite sure how to connect one letter to the next? That's what this lesson is for. As you'll learn, there may be one slight change to a stroke that can make the transition that much smoother.

WHEN YOU CAN'T TELL WHAT THE LETTER IS

If you were to show your word to someone else, would that person be able to read it? If the answer is no, the connection between the letters may be what is causing that. Try to get back to what the letter is supposed to look like. For example, the o-r connection of art 1 is preventing the beginning of the r from being fully shaped. The connecting stroke goes straight from the top of the o across to the r rather than starting down and then going up as most of the connecting strokes do as we learned in lesson 5. If you add a loop to the o (art 2), you'll be able to come around and start the connecting stroke lower to draw the r more clearly than before. Comparing art 3 to art 1, you can see the difference that little stroke makes.

Speaking of the r, this letter is tricky itself and can sometimes look off. One thing to be mindful of is the middle stroke. If that stroke comes across and dips down too low (art 4), it can start to look like a u or two separate letters. Think of that middle stroke as more of a diagonal line that comes down to connect; start high then go low (art 5).

art 1:

Corey

art 2:

Corey

art 3:

Corey

art 4:

Katrina

art 5:

Katrina

WHEN THE CONNECTION DOESN'T LOOK FLUID

Remember what we learned in lesson 6: that the foundation strokes are what make up each letter? When the connection between two letters doesn't look fluid, ask yourself if all of the strokes are similar to one another and if they mimic the foundation strokes. Take a look at art 6 for an example.

Q. Which connecting stroke doesn't belong
and looks different from the others?

A. The connecting stroke between the k and e.

To fix this, write the word again but this time smoothing out the *k-e* connection. Create more of a rounded *u* shape that mimics the other connecting strokes rather than a sharp *v* shape. This will allow the *k* to flow smoothly into the *e*.

art 6: art 7:

WHEN THE CONNECTING STROKE
MAKES A DIFFERENT LETTER

If this happens, check if you can alter the connecting stroke that created the extra letter. For example, on the *v-i* connection in David (art 8), the *v* looks more like a *u* because the connecting stroke came down after the *v* before the beginning of the *i*. If we change that stroke to come across rather than down (art 9), the problem is fixed, and you can now read both the *v* and the *i* clearly (art 10).

art 8: art 9: art 10:

If at any point you find yourself confused or wondering if you made the right connection, use these ideas as helpful troubleshooting tips.

Place Mats

I mentioned this project in the intro as one you can do in twenty minutes. Yes, you can! Don't say you don't have time. Now that you know a few of the tough connections that might come up, there's no excuse if you don't know how to write your friends names. Grab some large pieces of paper and your paint pen, and let's make your dinner together that much more meaningful with these place mats.

SUPPLIES:

paint pen

roll of kraft paper or construction paper

chalk

scissors

scratch paper

pencil

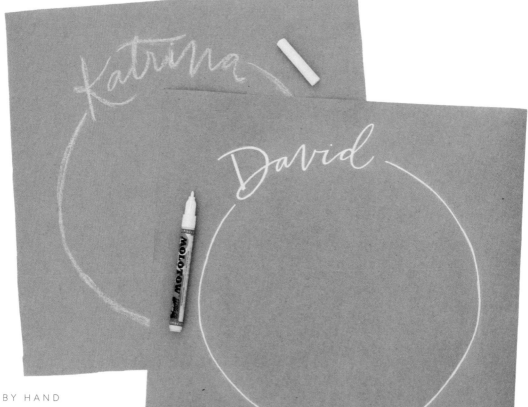

1.5 mm 2 mm 4 mm

1) Using either a roll of kraft paper or construction paper, cut sheets to roughly 12 x 18-inch or 13 x 13-inch. It's up to you if you want the place mats rectangular or square.

2) Practice writing your guests' names with a pencil on scratch paper. This way you can work out any of the connections you may be confused about. If you'd like a refresher on how to connect your letters, refer back to lesson 5.

3) Place a plate on the place mat to figure out where you want to write the names. Maybe you'd like to write them off to the side curved along the plate or centered at the top. Draw a line in chalk to mark your baseline.

4) Remove the plate and draw out each name in chalk. Have out your practice sheets for reference.

5) Now for the paint pen. Each brand has a few different tip sizes you can choose from depending on the size of your project. A few examples of the Molotow pens are show above: in 1.5 mm, 2 mm, and 4 mm. When you have yours picked out, review how to get your paint pen started on page 185 and practice on scratch paper first. Then remove the plate from your place mat and trace over the chalk lettering from step 4 to write the names out. Add the thick downstrokes as we learned in lesson 21.

Optional: Add a border or any extra elements. If you want to make a circle border, a trick is to flip the plate upside down and use that as your guide. Draw a circle a few inches out around the shape of the plate.

6) Put the place mats out, set the table, and enjoy time with loved ones! Your family and friends will feel special that you took the time to letter their names.

tip

Instead of making a template with pencil first like we've been doing in past projects, you can use chalk to draw the names out directly on the place mat. This way you can erase and fix anything you don't like before moving to the paint pen. The chalk will rub off with your fingers or a paper towel.

23

TRIAL + ERROR

[PROJECT: **FOUND OBJECTS**]

I'll never forget the first time I was asked to write on leaves. How cool is that, right? I get to write on leaves! Well, the story goes a little like this: I procrastinated until the last minute to get them done, and when I went to start lettering all 100+ names with the white gouache paint that I usually use, the ink bubbled up and wouldn't stay put. Panic. Nothing was open because it was late at night and the leaves had to be done the next day. More panic. I went into my messy pen drawer and found a white gel pen that had been sitting there for years. Bingo. For some reason that was the exact pen I needed.

The moral of this story is a thing called trial and error. It's a lesson that I've taken with me throughout this lettering journey and want to pass on to you. Every surface is different, and I don't want the frustration of the pen not working to stop you from continuing on. And guess what? Later on, you may find out another pen works better like I did with the Molotow Paint Pen I used here with these leaves. Now you can have a full stock of those pens ready for the next time.

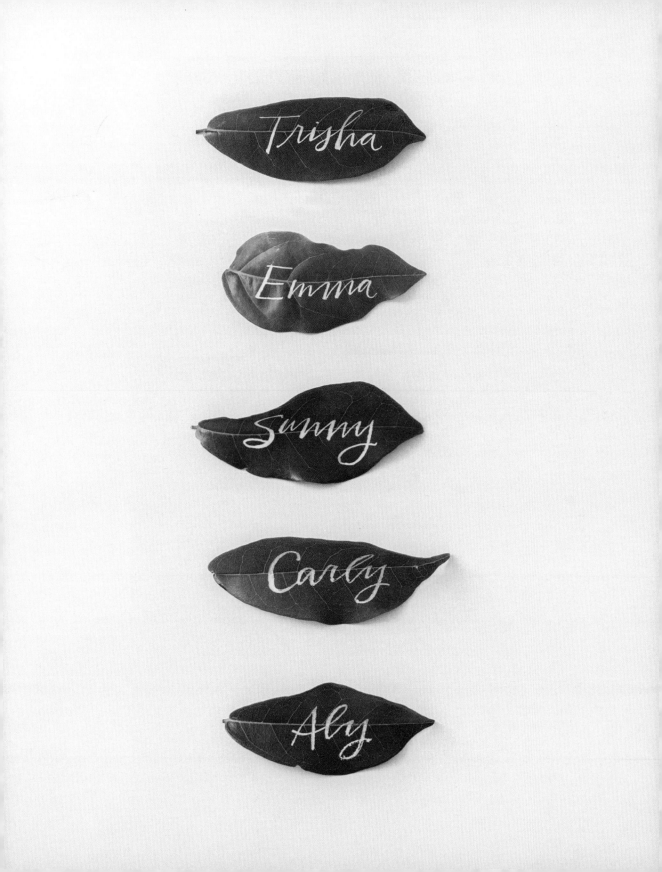

Before you start this lesson, do yourself a favor and go for a walk. Get some fresh air, get your eyes off of this book, and open to beautiful Mother Nature right outside your door. While you're at it, if you see a leaf on the ground or a rock that looks like it's itching to be written on, pick it up and meet me back here.

One of the many great things about modern lettering with pens is that you can draw on anything and everything. With that comes many new scenarios for your pen not to work. It's all about *trial and error.*

The reality is that there can be many factors as to why *X* tool won't work on *Y* surface. And the pen you typically use may not be the answer to the problem. It's like a science experiment: you never know what the outcome will be, and you have to play around before finding the winner.

Moving forward we will be lettering on surfaces other than paper, and it's important to note that there is not one pen that will always work for you. I suggest having a few brands in your toolbox. The Tools of the Trade on pages 12–15 has some great options to start with. If possible, I also recommend hanging on to extras of the material or surface you are writing on to be able to test the pens out. Here are a few **troubleshooting tips** to try if you find yourself in a situation where your pen doesn't work.

TROUBLESHOOTING TIPS

1) If you notice your paint pen running dry, reshake it and press the tip down on scratch paper. Sometimes the ink dries out and you need to give it some love. Be mindful that if you pump the tip too many times the paint may bleed out. Hence why I suggest testing things out on scratch paper.

2) Try a different type of pen. Know that sometimes, like in my introduction story, you will need to switch things up and use something different depending on the surface you are drawing on. In addition, if you're writing on a small area, like rocks or tiny sea glass pieces, even the smallest paint pens draw too thick of a stroke. I suggest trying out gel pens. My favorite brand is Gelly Roll as seen in the image to the right.

3) Try a different brand. Molotow, Pentouch, and DecoColor are a few of the paint pens I switch off between. Molotow is my favorite white pen because it is the most opaque, Pentouch is my favorite for its metallic colors, while DecoColor has lots of other colors to choose from. They also react differently on different surfaces, which is why I test them out each time to see what works best.

4) Make sure your writing surface is completely clean. Sometimes the oils from your hands can cause the ink to bubble up and not stay put. Use Clorox wipes, rubbing alcohol, Windex, all-purpose spray cleaner, or even just water to remove any oils or dirt.

5) The surface could be too smooth or have a clear coat over it preventing the paint from staying. Try either rubbing your finger pad across the surface or scratching it with your nails to break it up. Don't ask me why, but I swear this may work especially on marble or tiles.

6) If the lettering is scratchy or faint, go over it a second and maybe even a third time. Often on textured surfaces, your lettering may not look substantial enough after just one pass. Go over your strokes a few times to get the color to really show up. On the rocks below, I wrote Kelsie's name with one coat and went over the strokes a few times for Noelle's name.

If you've gone through these tips and your pen just isn't working, it may be time to get a new one. It's not you, it's the pen. But promise me as we continue on this lettering journey together you'll keep this lesson in the back of your mind and use any of the troubleshooting tips here if you run into a tough situation and panic. There are many new surfaces that we'll be writing on throughout the rest of this book, and remember life lesson Be a Problem Solver (page 158), go be person B.

Found Objects

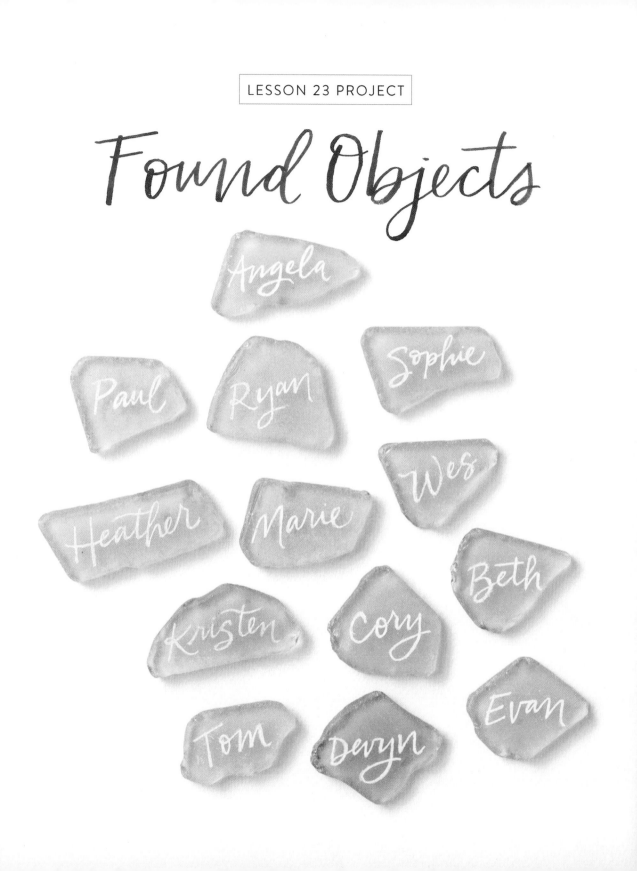

paint pen

gel pen

the rest of your toolbox handy

found objects

1) Look around your own home or yard or take a walk in a nearby park. What objects do you see that would lend themselves to modern lettering? If you're looking for something specific, Etsy is a great online website for objects like seaglass, driftwood, and pretty much anything you can think of. There are also a few resources on page 262 for other sites you can check out.

2) Pick one or two and try your hand at lettering on your found objects!

3) Remember to use any of the troubleshooting tips you just learned if you run into a situation where your pen doesn't work.

Have fun bringing your found objects to life in a whole new way!

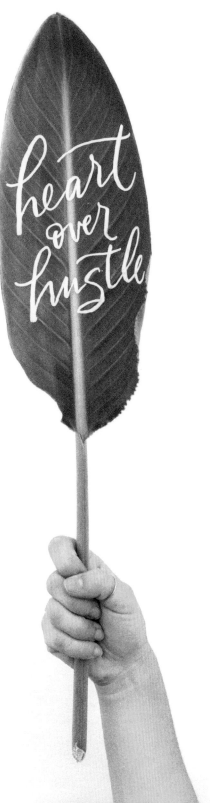

24

CAPITAL
LETTERS

[PROJECT: **COASTERS**]

Capital letters: these are most often used when we put the all caps button on our phones to tell our friends we are SO EXCITED!!! (I agree it's necessary to get your excitement across.) Although we don't often write modern lettering in all caps, we do use capital letters to start a sentence, at the beginning of our names, or to make a statement even if it's not every single letter of the word.

In this lesson, we'll think of the capital letters as pieces of the puzzle you are the designer of. How can you mix it up? Can you use them to create a home for the other letters? We'll end with a fun project lettering on coasters to keep for yourself or give to friends as they move into their new home and begin to make it their own.

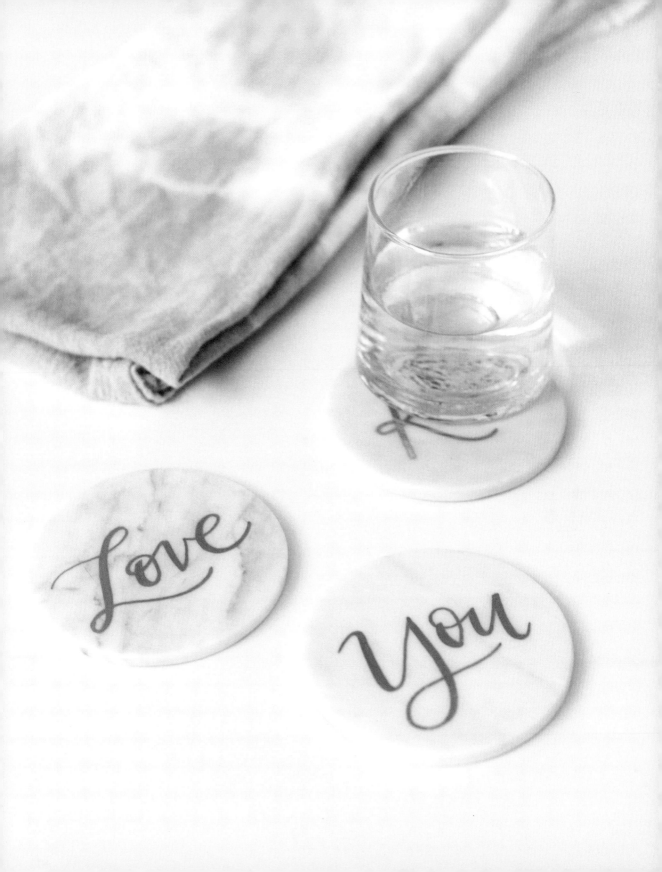

Do you know how to write all the capital letters in cursive—the proper way we were taught in school? *How do you write a cursive capital Z?* Yeah, I had to Google that too. If you're like me and don't remember them all, no need to fret. There isn't a rule book telling you to make them a certain way. To jog your memory, look back at lesson 2 or flip to page 253 for a few other styles to use as inspiration. In this exercise, I'll be lettering with the words *Cheers, Love,* and *You* as I'll be giving coasters to friends as their wedding present.

First, write out the word *Cheers* and play with different ways to write the capital C. Try to add in a loop or flourish like we learned in lesson 15.

Cheers

Cheers

Cheers

After you've written a few options, I have a question for you. As you were drawing the word *Cheers,* did the connection between the C and the h feel smooth? Did it flow from one letter to the next? If your answer is yes, I agree. There is a natural tran-

sition from the capital letter to the lower-case letter in this word. However, that isn't always the case.

Try writing the word *Love.*

Love

Love

Love

If you find yourself pausing to the think about how to connect the L and o, that's normal; it is an awkward transition. Now try writing *Love* again, but this time don't even try to connect the capital letter to the lowercase letter.

Love

Love

Love

That probably feels less awkward. Point 1: there's no rule book telling you you have to connect the capital letters. So if it doesn't flow, don't force it. Most of the time I don't connect them. Point 2: I like to think of the capital letters as making a "home" for the lowercase letters. The *ove* fits nicely within the *L*. It's a perfect little nest.

Let's try another word: *You*. Explore both connecting and not connecting the capital *Y* to the *o*. Also try adding a flourish both short and long to the end of the *Y*.

This capital-to-lowercase transition between the *Y* and *o* is smoother than in *Love*. Any of those options would be great. This lesson is less about telling you ways to write your capital letters and more about showing you *how* to use them. There isn't just one way, and remember modern lettering is not just your handwriting. You are drawing, designing, and crafting these strokes to create a design that feels like you. See what letters you're working with and experiment from there.

Coasters

Now let's use some of these words to letter on coasters to give as gifts or add to your home. You can use marble, agate slices, wood, or really any surface. Find what fits your personality, but remember it might require some trial and error (lesson 23) to find the right pen to use.

SUPPLIES:

paint pen

pencil

scratch paper

coasters

clear matte fixative

1) Trace the outline of the coasters on scratch paper. Sketch your final lettering in the circle to visualize the final piece.

2) Depending on the surface of the coaster, you may be able to use a pencil or chalk to draw the design directly on the coaster first. If that's the case, feel free to do so.

3) If you can't use a pencil or chalk on your coaster, you are still well prepared to write without a template, as you have your to-scale sketches from step 1 for reference. Shake your paint pen, test it out, and then go for it.

If you have more than one coaster, use the extra one as a hand rest under your wrist. This will bring your hand to the same level as the coaster you're writing on. (See photo on page 207.)

4) I suggest drawing the entire word first, then once it is completely dry, add the thick downstrokes.

5) Since these coasters will get wet from the drinks placed on them, you can spray them with a clear matte fixative to keep the paint sealed. Then they will be ready to find their new home and be used. Cheers!

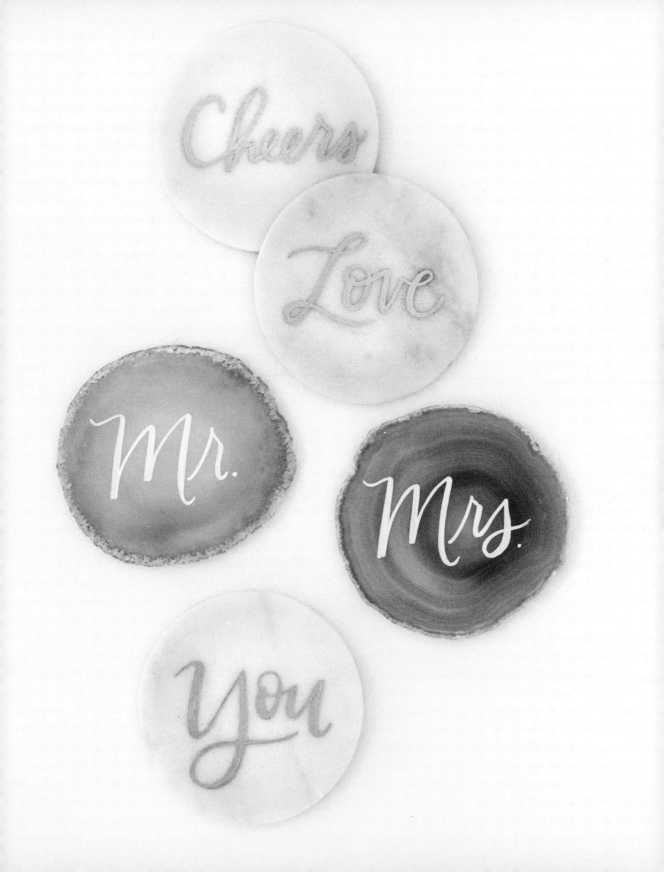

25

CHANGING UP THE CONNECTION

[PROJECT: CUPS + GLASSES]

We all have our go-to place we like to meet with friends. Let's meet for coffee, our usual spot. Happy hour after work, the one with bottomless chips and guac. Should we head to the pool this weekend? I heard it's supposed to be hot. No matter the location, these places involve a drink of some sort—your daily cup of coffee, a glass of champagne, a cocktail, your tumbler filled with lemonade to keep you cool. Most likely you don't think about what you want to drink at those places; you go straight for your usual.

What was the last thing you ordered at Starbucks? _____ Did you repeat your drink order without even pausing? Point proven. The same happens when you write your words out. You naturally write a certain way, forget to pause, and subconsciously do the same thing every time. This isn't a problem. However, I want to show you there are ways to vary your letters by taking a closer look at the connections within the letter itself. You never know if a slight change is something you may end up liking. Green tea instead of coffee? Cider instead of wine? Why not?

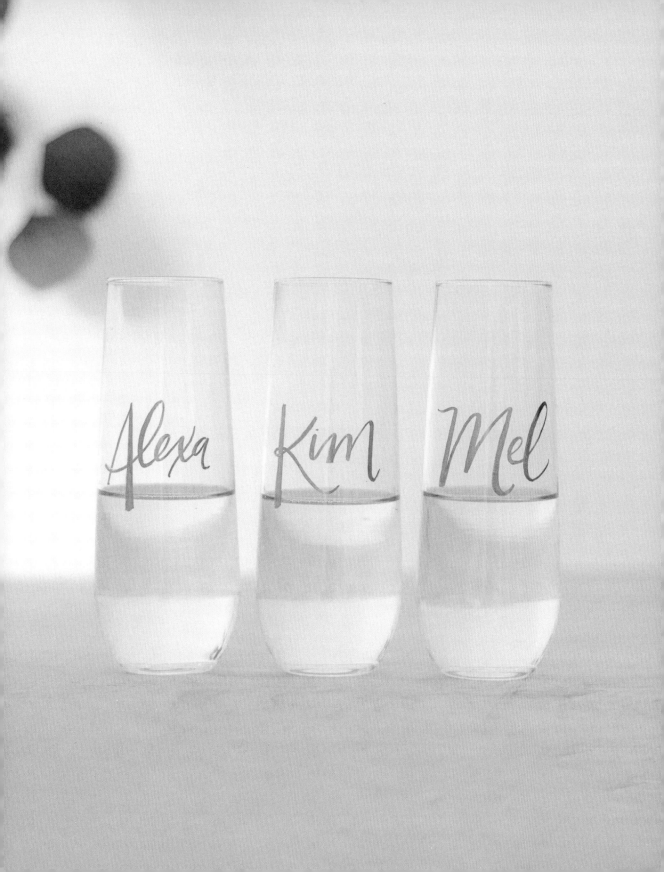

As you've seen, lettering with a pen is different than lettering with a brush. You aren't focusing on the amount of pressure needed to create the thin and thick lines, and you aren't having to remember to get more ink before your brush runs out. Because of this, it is easy to go on autopilot and write the same or similar to your normal handwriting. Again this is not a problem. However, if you're reading this thinking that you don't like your handwriting and/or this is just the way you write, then I challenge you to go deeper. Take a look at the examples below.

1) Can you play with where you intersect the second stroke? For example on the K and R in the art below, do you intersect high or low or in the middle?

2) Where do you begin your second stroke on the letters m and n? In the first examples of both *Mary* and *Jen* in the art below, the second stroke of the letter starts at the bottom of the first stroke (pink). Whereas in the second version, the second stroke of the letter begins higher on the first stroke (teal). Do these options feel different to you?

3) On letters like the y and a in Lucy and Sam, does the end of your first stroke stop high and connect to the top of the second stroke (pink)? Or do you end the first stroke lower and the second stroke leans up next to it (teal)?

Lucy

Lucy

Sam

Sam

4) Can you play with where you cross on the letters *A* and *H*? Do you typically cross high, in the middle, or toward the bottom? This also applies to *E, F,* and *t.*

→ *Alicia*

→ *Alicia*

→ *Haley*

→ *Haley*

5) Jumping off of point 4, do you cross your *t* with a straight line or a curved one? The same goes for your lowercase *x*: straight or curved?

Peter

Peter

Max

Max

In all of these examples, you can see that by changing the location of one of the strokes, you can create a different look even with the same letter. Whether it's where a stroke intersects, where it begins, or where it ends, this shows you there is more than just one way of writing each letter. So the next time you find yourself frustrated that this is just the way you write, revisit this lesson and try something new.

Cups + Glasses

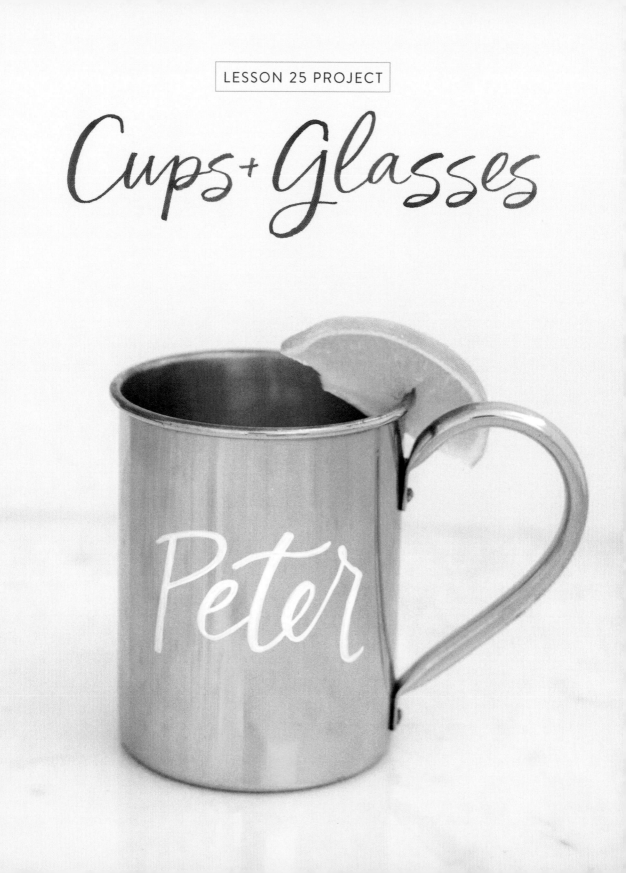

A great way to experiment with your style and connections is writing your friends' names. Do you have a cup you'd like to jazz up with some lettering, need a gift for a friend, or are planning a bridal shower and want to write everyone's names on glasses? One of the great things about lettering with pens is that you can write on glass, ceramic, plastic, metal, and the list goes on. I'd have a few pens ready to test out as each surface is different. Also know that these letters will face natural wear and tear, and hand-washing the final product is recommended.

SUPPLIES:

paint pen

drink/cup/glass of your choice

pencil

1) Clean off the surface to remove any oils that will prevent the paint from transferring. Any type of cleaning wipes or even a paper towel with water will work. Let your cup dry completely before lettering.

2) Depending on the surface, you might be able to draw out your design in pencil first. If so, do that here.

3) Now, for lettering on curved objects. Instead of writing with the cup standing up tall, I like to rest it up against something so it's leaning slightly at an angle.

Or lay the cup flat on the table and find something at a similar height—like a box or a stack of books—to rest your hand on (similar to the tip in lesson 24 with the coasters). If your pen isn't flowing, refer to lesson 23 for any troubleshooting tips.

4) Add in the thick downstrokes.

If your spacing is uneven between the letters (lesson 7), try using the downstroke lines to help you even it out. For example, in the word darling below, the space between the d-a and the r-l is larger than the other spaces. If you add the thick downstroke to the right of the d and the left of the a, that will take up some of the negative space and make it smaller. This way those spaces are closer in size to each other and you didn't have to go buy a new glass to letter on!

5) Call your friend up and meet at your favorite spot with your cool new drink. Don't forget to make one for her too!

26

MY FLOW

[PROJECT: **LETTERING ON ACRYLIC**]

First, take a moment to pause and give your hands some love. Wiggle your fingers, move your wrists around, take a few arm stretches over head. As much as this is a how-to lettering book, I am here to give you a little nudge to move your body and give yourself a break. You may have experienced how easy it is to get in the zone and not realize you've been hunched over your letters for hours on end.

Let it flow.

This same flow is what helped me develop my own style. It wasn't an immediate change and I can't say this is the exact reason, but once yoga came into my life, my lettering style started to change. In the beginning I wanted everything to be perfect. I would tense up, grip my pen supertight, and not even realize I was also holding my breath while drawing. I had to learn to breathe both in my personal life and my work life. I had to learn to let it flow.

This lesson will break down parts of my style that are a little different. I focus on the transitions and the strokes in between, creating a fluid movement that eases from one stroke to the next. By no means am I telling you you must go do yoga or that you'll find your answer in savasana. My hope is that by shedding some light on my personal way of lettering, it will open some windows for you to think about your own. When you combine your personal story with your modern lettering, you're bound to find your groove too.

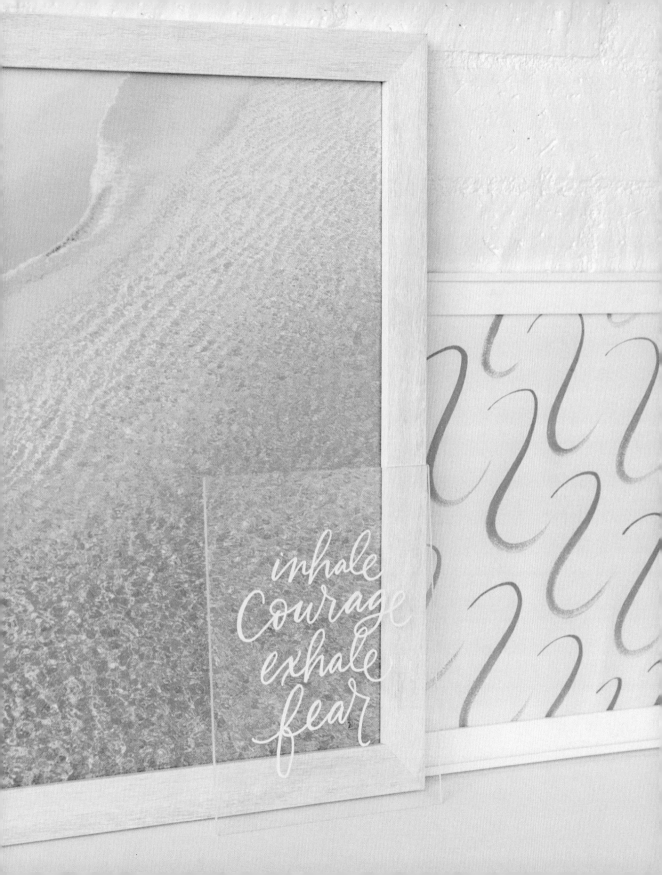

Before diving in, remember this isn't right vs. wrong. This lesson is simply breaking down and showing you a different way of writing. Here's an example. The two words below appear to be different, but can you pinpoint why? Take a closer look at the connection of the letters, where one ends and the other begins.

art 1: art 2:

inhale *inhale*

Can you see the difference now? In art 1, the *i* flows into the *n* in one continuous stroke. In art 2 you can clearly see where the *i* stops and the *n* starts. Instead of thinking about each letter as an individual item, consider them as strokes that flow from one to the next. Take a look at the breakdown of the strokes in art 3. The first stroke makes up the *i* and part of the *n*. Then the next stroke starts from there and ends halfway through the *h*. If it flows, it's okay that a stroke stops within a letter. When there is a strong stop at the bottom like on the *n* and *h*, that's a good place to end the stroke and then lift up to start a new one.

art 3:

inhale

Another opportunity to create a flow is on the rounded letters like *a*, *d*, *g*, *o*, *q*. I end the connecting stroke up and over the *a* high instead of low. I call this "setting myself up." I draw a hump to put myself in position to draw the curve of the *a*. Then I overlap back over that stroke and draw the *a* as normal.

art 4:

To show you the difference if I don't set myself up, compare art 5 to art 6. The stroke stops toward the bottom before the *a* and *g* in art 5, whereas that same stroke in art 6 is extended to flow into the top of the *a* and *g* creating a seamless stroke.

art 5:

art 6:

courage *courage*

One last connection to shed light on is between the letters with a loop. For example, the *h*, *l*, and *e* of the word in art 7 and 8. If you look closely at the circled connections in art 7, you can see the loop of the *h* doesn't quite line up with the end stroke of the *x*. The same is happening between the *a* and *l*. Instead, in art 8 I made these connections one fluid motion. The *a*, *l*, and *e* at the end is one long stroke continuous stroke. This is the flow.

art 7:

art 8:

exhale *exhale*

As you look at these different ways of connecting, take a moment to try this out on your own. Start by writing the word the way you normally do. Then using marker paper, trace over that word, but try and change up the connections. See if there are any opportunities where you can connect with one long stroke or set yourself up. Remember that neither is right or wrong—just different ways of connecting. This is the how.

Lettering on Acrylic

If you're looking at the photo here and wondering what the white lettering is written on, it is a thick hard plastic called acrylic, the same material often used for displaying your most prized possessions. Acrylic is also a great surface to letter on and can be used to create an unexpected art piece or as signage for your next event. It comes in several thicknesses (this one is ¼-inch for reference) and can be purchased precut or custom cut online. Check the resources section on where to purchase acrylic.

SUPPLIES:

paint pen

acrylic board

pencil

scratch paper

pen or brush pen

paper towel

tape

1) The beauty of acrylic is that it is completely see-through. Because of this, make a template on scratch paper to trace over first. This is your opportunity to put all that you've learned together. Start with thumbnail sketches like we learned in lesson 14 and go through the process of making the design bigger from lesson 20. Also think about the connection between your letters from this lesson.

2) Tape the template to the back of the acrylic piece facing up so you can see the design showing through. Use washi tape or painter's tape that can be easily removed without leaving a sticky residue.

3) Clean the acrylic with Clorox wipes or rubbing alcohol.

4) Put a paper towel under your writing hand, and trace over your design with a paint pen. The paper towel will keep the oils from your hand from transferring onto the surface as you're writing. If you make a mistake, you can wipe it off with Clorox wipes or Windex even if it's dry. That's one of the perks of lettering on acrylic.

5) Add the thick downstrokes.

6) When you're done tracing, remove the paper from behind the acrylic and look at what you made! Acrylic is beautiful as is and can rest up against a wall on a shelf or be placed in a stand. If you're looking to add some color, refer back to the bonus lesson from lesson 13 and make a full watercolor wash on watercolor paper to put behind the acrylic. This will create a fun backdrop for the lettering to pop!

7) BONUS: Now that your eyes are open to the world of lettering on acrylic, try writing on acrylic trays, jewelry cases, pen holders, and more. Have fun!

Why Not?

WHAT IS THE WORST THAT CAN HAPPEN?

A friend asked me this question when I was dating someone special. And my answer was simple: The worst that can happen is we go our separate ways. And guess what? That exact thing happened, and here I am today, completely okay.

So now I ask you the same question: What is the worst that can happen on this lettering journey? You might make a mistake. You don't end up liking the end result. You spill your ink, and it gets everywhere. Well, guess what? If that's the worst that can happen by trying these projects out, I'd tell you, just like my friend said to me that day . . . you will be okay, I promise.

YOU ARE GOING TO MAKE MISTAKES AND THAT'S OKAY.

I have misspelled words, completely forgotten words, and written the wrong name before. Yes, all of these scenarios have really happened to me. Each time I sit there and think, "Noooooooo, did I really just do that?" I give myself time to get mad, grunt a few times, run around kicking and screaming—okay maybe not that dramatic!—but then I get myself together and remember that I am okay. It's not the end of the world, and I can redo it.

YOU MAY NOT LIKE THE END RESULT.

A little piece of advice: You are probably the only one who will notice. You are your own biggest critic, and I can understand you want your work to be perfect. But remember perfect isn't what we're striving for. If you don't like your lettering because you're comparing it to someone else's work, go back and read the life lesson on page 182. If you're sitting there frustrated but don't know why—you just know something's off—try going through any of the troubleshooting tips at the end of each section. That is what they are there for. You have all the tools you need.

YOU WILL SPILL YOUR INK, AND YOUR PAINT PEN WILL LEAK.

From the look of my desk and the little traces of evidence on my clothes, I wear my mistakes every day. You will spill your ink. You will smear your paint at some point. Your paint pen will decide to explode at the wrong time and wrong place, i.e., as you're on the last of 150 place cards for your best friend's wedding. Not cool.

Although I don't have a magic trick for you (I really wish I did), what I have learned is to anticipate what could happen. Always ask for extras. Designate an area of your space as your place to paint that is okay to get messy. No one is perfect, so don't expect yourself to be either. Work smarter, not harder.

Now with those scenarios written out for you to see, I'll ask you the question: Why not?

27

THE DOUBLE LETTERS

[PROJECT: **WELCOME WOOD SIGN**]

You walk into a venue and the first thing you see is a beautiful sign that welcomes you: "welcome to the wedding of (insert name) and (insert name)." The mood is set, love is in the air, and the sign is a picture-perfect spot to capture the moment.

Let's say in a few months, your best friend is getting married, and she asks you to make her a welcome sign. You want it to be perfect. While going through your sketches and planning the layout, you come across the double d's in the word wedding. What you sketched out looks okay, but feels a bit stiff for the fun vibe of her big day. I've got you covered. In this lesson we'll play with the double letters and how you can mix it up. You'll be able to create movement with your letters so the words dance, just like the dance party of the century that's about to happen.

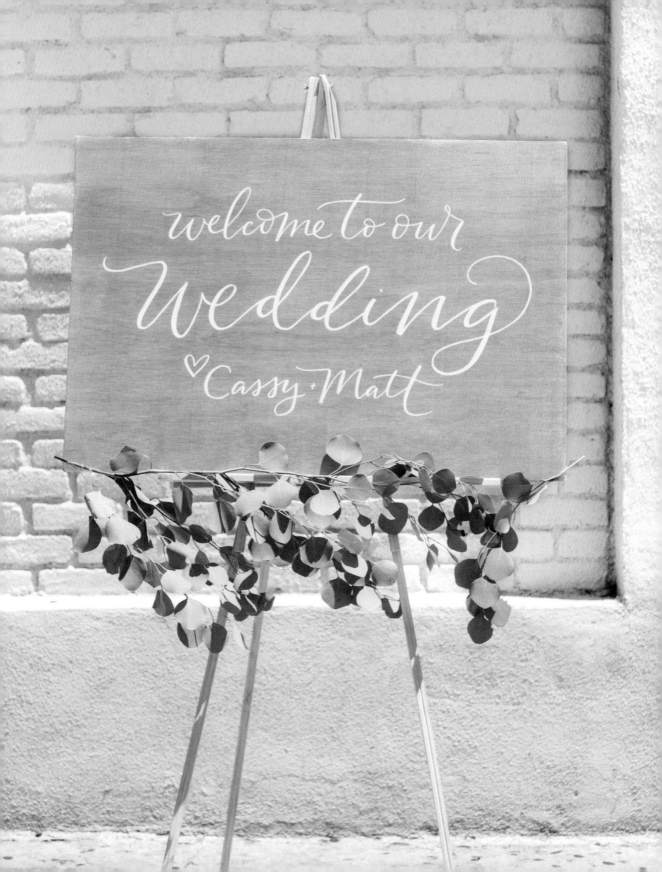

When a word consists of letters that are all around the same height, for example the letters in art 1, the word can feel stagnant. However, the same letters are used in art 2 and yet that word feels very different.

Here's why. Remember what we learned in lesson 16 about bouncing our letters? They don't have to all sit on the invisible baseline and be the same size. Small changes to the baseline and the size of the letters themselves help guide your eye through the word (art 2). With that in mind, let's work through some double letters and use this same concept to create variations.

art 1:

movement

art 2:

movement

STAGGERING THE DOUBLES

Looking at *wedding* in art 3, both of the *d*'s are written the same way. To give it some variance, try raising the baseline of one of them to create a staggered look (art 4 + art 5). The size of the *d*'s didn't change, but by shifting one above the overall baseline, the word has a bounce to it.

art 3:

wedding

art 4:

wedding

art 5:

wedding

MIXING UP THE SIZE OF THE DOUBLES

Another way to add movement is to actually change the size of the letters. Looking at *beginning* in art 6, we see all the letters are the same height minus the *b*. Let's find out what happens if we make one of the *n*'s bigger (art 7) or smaller (art 8).

art 6:

beginning

art 7: *beginning* art 8: *beginning*

Both new versions are unique, and those small changes have added charac-ter to the word. Now, let's take it a step further. Thinking about balance, can you make any of the other letters bigger or smaller? Starting with art 7, let's try mak-ing the first *g* and the last *n* bigger to complement the bigger first *n*. This helps to create balance, add bounce, and guide your eye over the entire word (art 9).

art 9: *beginning*

NOT CONNECTING THE DOUBLES

Remember what we learned in lesson 24 with the capital letters—that you don't need to always connect them to the first lowercase letter? The same can be applied here with the double letters. For example, on *happily* the first *p* doesn't have to connect to the second *p* (art 10). In addition, you can take the concept of staggering letters and end one of the *p*'s lower than the other (art 11).

art 10: *happily* art 11: *happily*

As you move forward on your own, remember the tip from lesson 16: *Prac-tice with a purpose.* Try out a few ways to letter your word or phrase, take a step back, and see what you like and don't like. Then try something different or build off of the parts you do like. This is a great way to get out of your comfort zone and do something new.

Also remember these are not hard-and-fast rules you always have to follow. Just try these out if you're looking to add some movement to your own words.

Welcome Wood Sign

welcome to our *Wedding*

♡ Cassy · Ma

happily ever after

Like we saw in lesson 15, wood makes a great surface to letter on. We painted using a brush and white ink then, but for this project we'll be using a paint pen. What's the difference? There is none really. It's like the double letters, they're essentially the same, but you can switch them up slightly to create a new look. Let's try it out.

SUPPLIES:

white paint pen

chalk

painter's tape

wood

scratch paper

paper towel

clear matte fixative (optional)

IF YOU ARE STAINING THE WOOD:

wood stain

sandpaper

gloves

paint mixing stick

large wide brush or cloth

1) Purchase wood either precut at a craft store or custom cut at a home improvement store. For reference, the *welcome wedding* sign is 24 x 36 inches.

2) Work through your thumbnail sketches on scratch paper as we've learned and finalize the design you'll be drawing. Have that out for reference.

3) Did you know that you can change the color of wood by staining it? If your local store doesn't have the wood you want, go to a home improvement store and purchase wood stain. While you are there, buy sandpaper, gloves, and a paint mixing stick. The *welcome wedding* sign in the photo is the same exact wood as the *happily ever after* sign—but with wood stain painted on it.

How to stain the wood:
* *Designate and cover an area to stain in. I cut brown paper bags or use big garbage bags and lay them out to cover the floor.*

* *Sand the edges of the wood using your sandpaper.*

* *Mix the stain with a paint mixing stick.*

* *Use either a large wide brush or a cloth to paint the stain on the wood. One coat is plenty.*

* *Let the wood completely dry (I suggest overnight) and make sure to do a touch test before lettering. If it feels sticky or damp, it's not ready.*

Then continue with step 4.

4) I suggest using chalk to draw your design on the wood first rather than going straight in with the pen. This way you can get the final look nailed down and feel confident about it. There are a few ways to make your design bigger.

Draw a grid with chalk. Refer to lesson 20 for how to increase the size of your sketch.

Use painter's tape to mark the lines of where to draw the design.

Freehand the design.

5) Now we're ready for the paint pen. Since these signs are larger, I'm using the bigger tip Molotow Pen size 4 mm. Shake your paint pen, press the tip down, and test it out on scratch paper. When the paint is flowing from the pen, trace over your chalk sketch. If the chalk dust is preventing the paint pen from writing on the wood, use a paper towel and remove some of the excess chalk that you don't need. In addition, have scratch paper handy to write on and remove the chalk from the tip of the pen.

6) Once the phrase is complete, go back and add the thick downstrokes as seen in the photo to the right. You can also see the difference before and after the thick downstroke comparing the *welcome wedding* sign on page 228 (before) to page 225 (after).

7) After the lettering is completely dry, use a paper towel to gently remove the chalk.

8) Optional: Coat the wood with a clear matte fixative to waterproof it.

9) Place your sign on an easel or lean it up against a wall and watch the guests enjoy your creation! You'll want a picture with it too. You should be proud.

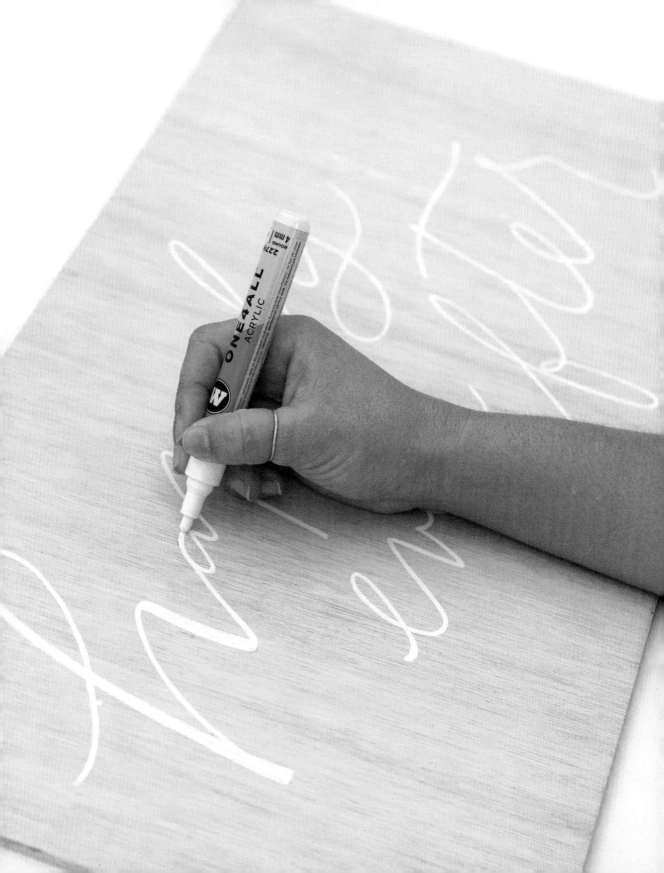

28

THE ENDS
+ bonus embellishments

[PROJECT: **THANK-YOU BAGS**]

You're about to leave a really fun party. The food was great, and you saw old friends, made new ones, and danced the night away. As you walk out the door, you are handed a goodie bag filled with treats and feel like a kid in a candy store. And to top it off, the bag has a fun design on the front that makes you want to keep it. The hosts thought about it all: the beginning, middle, and end . . . leaving you with a great lasting impression.

When it comes to your letters, have you stopped to think about how you end a word? Does that stroke curl up, does it loop up, does it have a hard stop? In this next lesson, we'll take a closer look at what you naturally do with your letters and show you how the ending stroke can be another way for you to craft your own style.

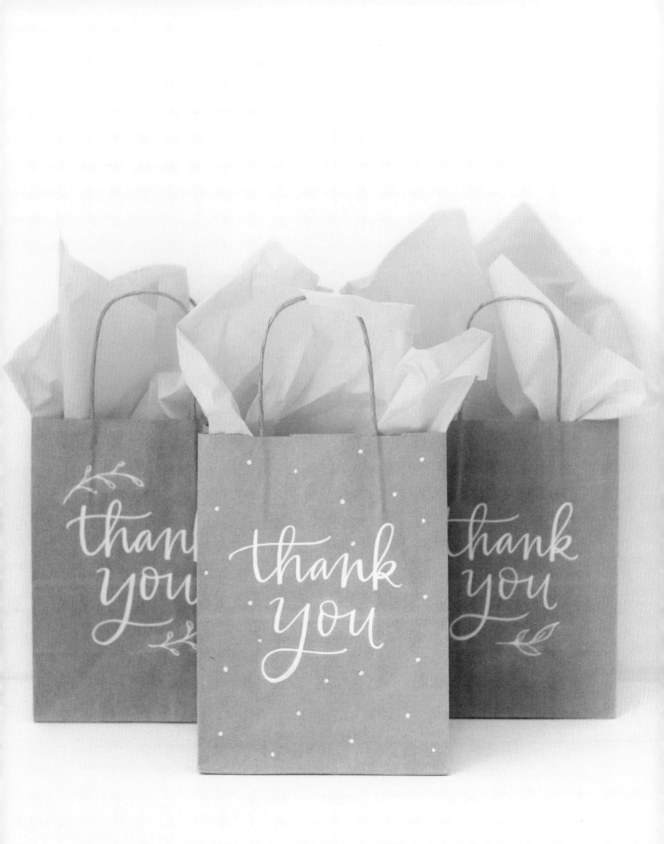

First, I'd like you to draw some sketches of the phrase *thank you*. Don't think too much about it; just get a few ideas out on paper. Then take another color pen and circle the ends of your words: the end of the *k*, the *u*, and the cross stroke of the *t*. Looking at these ends, are they the same or are they different from one another? Maybe one curls up and one curls down. Or maybe one stops without curving at all. Please know that whatever you have in front of you isn't wrong. Most likely, you hadn't put much thought into the ends before this lesson. But what you'll soon see is that being mindful of these ends helps to create a cohesive and unified design. Let's get started.

In the design in art 1, the ends of the *t*, *k*, and *u* are all different. One is straight, one is curved, and one is slightly curved. Let's make a small addition and extend the end of the *u* to mimic the curve on the *k* (art 2).

Then let's do the same with the *t* and curve the cross stroke to also mimic the *k* and *u* (art 3).

Are you starting to see the difference? Making these end strokes similar to each other unifies the design. We are no longer thinking of these as individual words; it is one phrase and one cohesive design.

We can apply these concepts to the beginning of our words as well.

To take our sample a step further, add a curved stroke to the beginning of the y similar to the beginning of the t (art 4). This subtle adjustment makes the letters look unified and flow together. When someone looks at your design, you want them to think nothing of it because that's how "right" it feels. No one needs to know you did it on purpose. You have the little secret why.

art 4:

There's one more insight to share with you. Remember how we talked about the space between the letters back in lesson 7? On a similar note, let's take a look at the white space around the design. Do you see the negative space below the ou that is created from the bottom of the y hanging out on its own (art 5)? The design feels unbalanced because of this gap. What if we chose not to connect the y and to add a flourish (lesson 15) to fill that negative space (art 6)? Now that feels more balanced.

art 5:

art 6:

All of the options we went through are great, and one isn't better than the other. The idea here is to get you to look at your own words and notice the ends. What are your natural tendencies? Are they similar to each other? Do they add to your design or do they distract from it? There is a reason when you look at something and it just fits nicely together: it was designed to be like that. You are the designer and can add or make any little adjustments to fit your letters just so. Give it a try on your own words.

Thank-You Bags

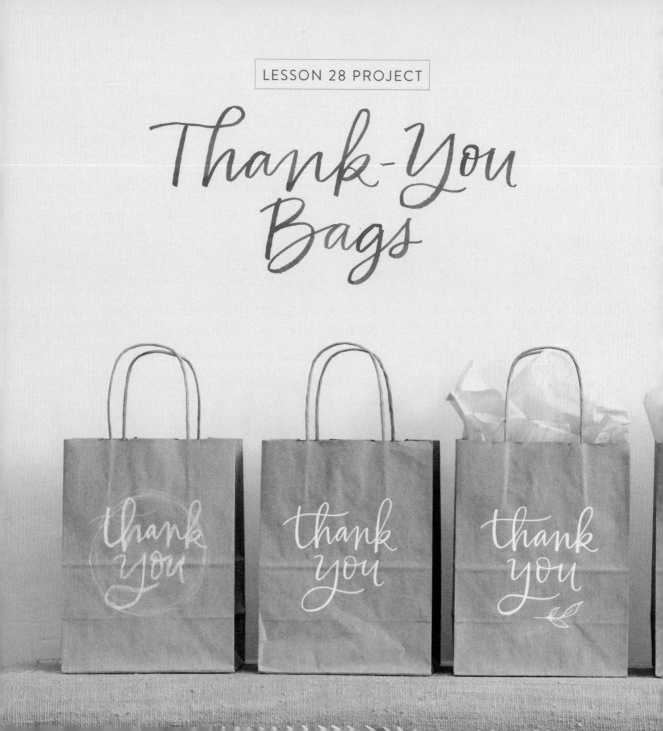

Are you someone who skips the step of wrapping presents in actual wrapping paper and puts them in bags instead? That's me too. Now, you can add some lettering to the front of those bags and make them feel extra special!

SUPPLIES:

paint pen

paper bags

chalk

scratch paper

1) Before even taking out your paint pen, envision what the final product will look like. Draw a rough circle in chalk on the front of your bag where you think the design should go. Then open up the bag and see what it will look like. If you drew the circle too high or low, too small or too big, you can adjust that here or in step 2.

2) Continue using chalk to sketch out your full design like the first bag in the image to the left.

3) Shake your paint pen, test it out on scratch paper, and then draw directly on the bag. If the chalk dust is preventing the paint pen from writing, use a paper towel to remove some of the excess that you don't need. In addition, have a scratch paper handy to write on and remove any chalk that gets on the tip of the pen.

4) Add the thick downstrokes.

5) When the design is dry, use a dry paper towel and rub the chalk off. It's that simple. These bags have been waiting for the day you decided to write on them!

BONUS LESSON:
EMBELLISHMENTS

If you're done with these steps and your bag looks a bit bare, although you can't redo the lettering, you can always add some embellishments. Maybe polka dots or lines that look like a sunburst would do the trick. Or feel free to use any of the leaf illustrations below to add to your design and fill in the white spaces around your lettering. This can be a fun way to give your designs some character and jazz them up like the ones on page 233.

29

COMPOSITION

[PROJECT: **PILLOWCASE**]

You are now tapping into that artist inside you—yes, you. We started this journey together with the foundation strokes and turning them into the ABCs. Then we built upon that firm ground to connect letters and come to understand modern lettering as more than just your handwriting. And now we're putting it all together and becoming the designer crafting how to fit the words together to create a unifying composition.

When thinking of designing your room, you might envision what items you want in it. What pieces are your core necessities? Which ones are your accent pieces? The same concept can be used when designing a quote. You start with the quote (your room), try out different layouts and ways to draw it (designing your room), and then add any extra elements that support and unify the quote (the accent pieces). The final design usually doesn't happen on the first try. It takes working through different combinations to pinpoint the one that grooves with you. In this lesson, we'll work through these steps and design a pillowcase to add to your room. You can choose whether it will be the focal point or an accent piece. You are the designer.

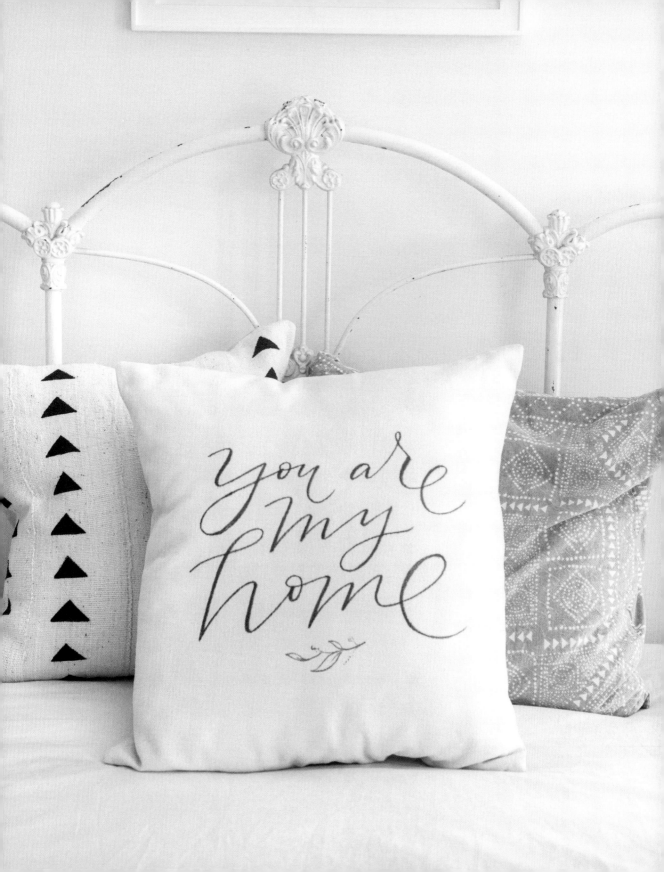

When you are lettering within a specific area—for this project on a pillowcase—it's helpful to draw that shape first for your thumbnail sketches. This way you have a frame of reference for visualizing the space you're working within. I'll be lettering on a square pillowcase, so my sketches will have square borders. Let's try out some thumbnail sketches using the phrase *you are my home*.

art 1:

What layouts work for this phrase?

- *two lines vs. three lines vs. four lines*
- *at a diagonal*
- *left justified vs. right justified*

What styles work with this phrase?

- *open up the spacing (lesson 7)*
- *angled vs. straight (lesson 9)*
- *oval vs. circular (lesson 10)*
- *using block fonts (lesson 16)*
- Home *capitalized (lesson 24)*

Are there any additional elements that work with this phrase?

- *flourishes (lesson 15)*
- *extending the entrance and exit strokes (lesson 28)*
- *leaf illustrations (lesson 28)*

As you go through your own thumbnail sketches feel free to use this checklist as a starting point; add to it, remove a step, switch the order, whatever feels right. There isn't a specific order to follow or a one-way ticket to the final destination. You'll have to work through various combinations to find the one you like. The idea of this stage is to explore, try things out, and see what works and what doesn't.

Once you've worked through your sketches and have the final design, there's one more exercise to do before we letter on the pillowcase. As we touched on when executing the thank-you bags in lesson 28, part of creating a design is thinking about the negative space: the empty space around your design. Draw a few squares a little bigger and play with the size of your design within that shape. Does it take up the entire pillow and extend closer to the edges, or is it smaller and in the center?

Again there is no right or wrong; it's based on personal preference which direction you go. Think of the design as needing its own breathing room. If it is too small, it can get lost amid the negative space, but too big can feel cramped. You are the designer, so choose what feels right for you.

Pillowcase

Ready to add to your home decor? This project will be fluffy and perfect for you to cozy up to.

SUPPLIES:

fabric marker

pillowcase

pencil

scratch paper

tape

Sharpie or dark pen

1) Either find a pillowcase that has a zipper so you can remove the pillow insert, or purchase the cover and insert separately. Fun fact I learned while doing this project, the pillow insert is larger than the pillowcase. My pillowcase is 20 x 20-inch but the insert is 22 x 22-inch. Now you know too.

2) Here's the secret to lettering on your pillowcase—make a template smaller than your pillowcase so you can slip it inside to trace. In this case, I taped 4 pieces of computer paper together to make a 17 x 22-inch rectangle (8.5 + 8.5 x 11 + 11). Then cut it down to a square to match the square pillowcase.

3) Draw your design larger on this template. To do this, make a grid over your final thumbnail sketch and the same grid on your paper template. Then draw section by section the lines and shapes you see in each quadrant. Refer back to lesson 20 for a refresher.

 If you're not a fan of drawing with a grid, another way to make your thumbnail sketch bigger is to use the middle of your design as your guideline point. Start writing *my* in the middle and add *you are* above and *home* at the bottom.

4) Once that's complete, draw over the final pencil sketch with a Sharpie or a dark pen to make the template easier to see through the pillowcase.

5) Open up the zipper and slip the template to the middle of the pillowcase. If the fabric is thin enough, you'll be able to see through it without needing a light source. If not, tape the pillowcase with the template inside to a window with sun shining through like we did in lesson 20.

If you're lettering on a darker pillow or the fabric isn't see-through, you can do step 3 with chalk to sketch the design onto the pillow directly. If this is the case, you'll skip steps 2 and 4.

6) Using your fabric marker, trace your design on the pillowcase. Unlike paint pens, fabric markers can be used right when you open the cap, no shaking required. It may be helpful to have a bigger pen since you're covering a larger surface. Then thicken the downstrokes.

7) Stuff the pillowcase and add it to your home. Kick back, relax, and enjoy!

Share your Light

As we near the end of this book, there's one more life lesson to leave you with, and it's one you're probably familiar with from when you were young. I'm talking about how to share. Sharing *has different meanings and plays different roles in the many stages of life. As a kid . . . you share your toys, your snacks, your colored pencils. As an adult, you share the road, your time, what you have and give to others. And at the stage you are in right now, it means sharing what you create.*

You may be reading this thinking you're not ready to share. It's intimidating to put something out there for everyone to see. Why would I put myself in a situation to be critiqued? No, thank you.

I'll be the first to tell you that I don't like being the center of attention. I am the girl who is quiet in big groups. I'd rather not talk; I like to listen. I started painting because I needed an outlet, somewhere that would be a safe place. And I also didn't feel like I was "ready" to share what I was doing with others. But along this journey, someone wise told me that I wasn't helping anyone by playing small. And that hit home. It changed the conversation, my mentality, and how I chose to show up in the world.

With lettering, you don't have to be the center of attention, and you don't need to show off or try to get hired for your craft. But you can use any of these projects to make a gift for a friend, offer to make signs for the next party on your calendar, or share your new adventure of lettering on social media and invite people to join in. Share the light. You never know who you may impact by simply being the invitation.

30

VISUALIZE + EXECUTE

[PROJECT: **BALLOONS**]

You did it! Hooray! Yippee! Here we are at our final project together. You now know that modern lettering isn't just your handwriting and that there are many ways you can design your letters. That even the smallest changes can create a whole new lettering style for you to use. We've also gone through the process of starting with an idea, creating thumbnail sketches, and making it bigger. And finally we've looked at how to visualize it on a final product and execute it.

Now I'm giving you a peek into my thoughts to show you that I go through this same process we've learned here together too. I want you to be confident moving forward that you have all the tools you need to continue doing this on your own. You have been designing, creating, and visualizing what you want the final product to look like and then executing it. And what better way to celebrate all of this than to blow up some balloons, letter on them, and have a party! You deserve it.

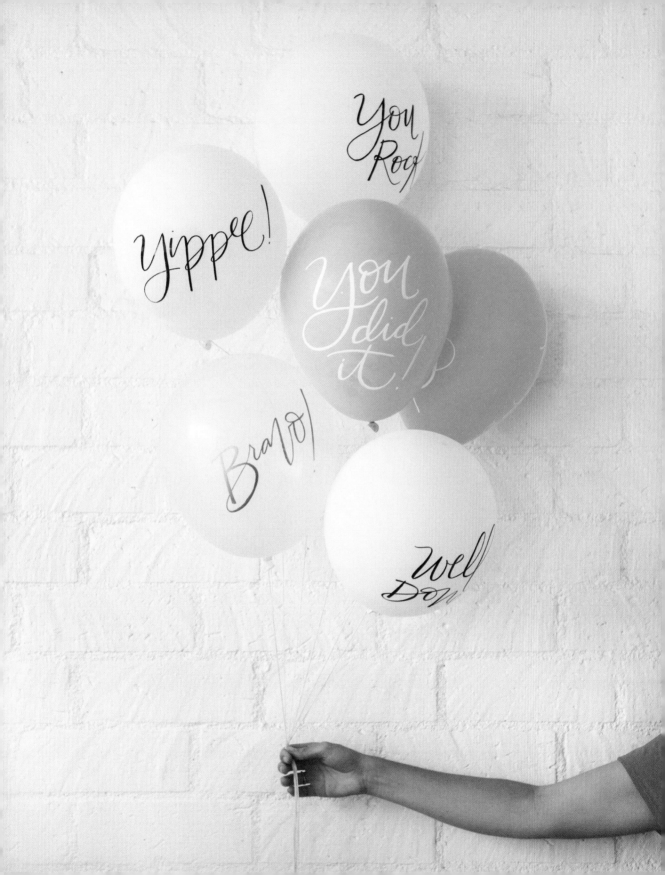

Here's a snippet of the process:

"I'll start with the phrase *You did it!* Should the lettering be angled or straight?"

"Angled. I like that look for these balloons."

Now for the layout. "Should each word have its own line or do two lines look better?"

"Hmm, it gets a little wide on two lines, and since it's on a balloon, the design would probably look better taller rather than wide."

"Should I open up the spacing? No, it also gets a little too wide for the balloons."

"Do the letters look better as tall and skinny ovals, more circular, or in between? I like in between."

"How does it look with *did* or *it* in all caps? That's an option."

"What does it look like with a capital *Y*? Nope not a fan: it creates an empty space above the *ou*."

"Okay, now I want to go back to the oval sketch. Is there anywhere I can add bounce to the letters? Make the o smaller? The d at the end bigger? It's feeling off balance at the moment."

"Last thing, straight or curved line for the cross of the *t*? I like curved. Just make sure the end of the *y* matches the cross of the *t*. Yes, that's the winner! All set and ready to rock and roll."

"What about making a home and not connecting the *y*? Yes! Or I could make the end of the *y* longer so *did* and *it* can fit below to it? Maybe too much. What about the *y* stopping right before the top loop of the *d*? I like that one!"

Now that we went through this snapshot, did you spot a few of the lessons from the book? We worked our way through playing with the angle (lesson 9), spacing between the letters (lesson 7), and shape of the letters (lesson 10). Trying out block fonts (bonus lesson 16), the bounce (lesson 16), and creating a home (lesson 24). Then we looked at how to change up the connection with the crossing of the *t* (lesson 25), refining the design with the ends (lesson 28), all while going through the thumbnail process (lesson 14).

This is the how. You experiment, try different things out, then take a step back to see what you like and don't like. The designing stage can be as short or as extensive as you'd like. By going through these steps, you are able to visualize, design, and then execute, rather than cruising on autopilot and simply writing with your natural handwriting.

Try this out on your own, pick a phrase to add to your balloons and create your final design. Then meet me back here to execute our last project together!

Balloons

SUPPLIES:

paint pens

balloons

string

helium tank

scissors

1) First, blow up your balloons, tie string around the end, and based on prior experiences of losing balloons to the sky, either add a weight to the bottom or tie them to something so they won't float away.

2) As we saw with the drinks and cups in lesson 25, writing on a curved surface adds its own challenges. With balloons, what I found to work best is to use a table that is right up next to a wall. This way you can lean the balloon against the wall and use your free hand to hold it there, giving you three touch points to keep the balloon stable as you write.

3) As far as figuring out where to start writing, my tip is to use the skills you've learned for visualizing the design and eyeballing the amount of space it will be taking up. Can you break your design into thirds or in half? For this quote, I started high in the upper third of the balloon with *you* because I knew I had two lines I needed to fit below it. In addition, since the balloon gets skinnier at the bottom, think about drawing the design a little higher. If you go too low, your beautiful lettering may not be as visible.

4) Now you're ready to execute. Have your design out from this lesson for reference and your paint pen in hand. Remember to test the pen on paper and draw a few strokes to get the ink flowing. Then go for it.

5) Don't forget that you're lettering on a balloon. It can pop. So don't put too much pressure on the balloon when writing. Also, be careful that the tip doesn't catch on the balloon and pierce it. I recommend the medium- to larger-tip pens as they also are great to

cover a larger surface area. I used the white Molotow pen, the gold Pentouch pen, and the black DecoColor pen. It's fun to mix up the colors!

6) When the paint is dry, go back over your letters and add in the thick down-strokes.

7) Double-checking that your balloon is tied to something, take a step back and look at what you just made! If you're looking at it and feeling like there is too much negative space, can you add an embellishment like we learned in lesson 28 to fill in some of that area? Or can you make your mistake into a flourish somehow (lesson 15)? These are some tricks to make whatever you did look intentional! Continue with other designs, invite your friends over, and celebrate!

PENS:
IN A NUTSHELL

REMINDERS

- Modern lettering can be created with any pen (lesson 21).

- Mix up your style by being mindful of the connection points within the letter itself (lesson 25) and the connecting stroke between the letters (lesson 26).

- Make a cohesive design by being aware of the ends (lesson 28).

- Use a window as a big light box for larger projects (lesson 29).

- Visualize the design on the final product first, then execute (lesson 30).

TOOLS

- Paint pens (intro to pens section).

- Gel pens—great for writing on small items (lesson 23).

- The pencil is your friend.

- Use chalk like a pencil (lesson 22, 27, 28).

- Fabric marker (lesson 29).

TROUBLESHOOTING TIPS

- To check if you're adding the thick downstroke at the right spot, draw the same word with a brush or brush pen and compare (lesson 21).

- There will be some tough connections that you can work through (lesson 22).

- Trial + error (lesson 23).

THE LIFE OF PAINT PENS

- Put the cap on tightly. This is even more important than with brush pens. Paint pens dry out quickly.

- After each use, you'll have to reshake the pen to get the paint flowing again and press down on the tip one or two times. Remember to do this on scratch paper as it might explode with paint.

- If you've shaken the paint pen, pushed down on the tip a few times, and then shook it more, it may be dried out or out of ink. It's time to get a new one!

ADDITIONAL STYLES

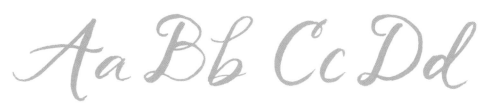

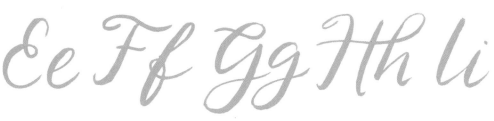

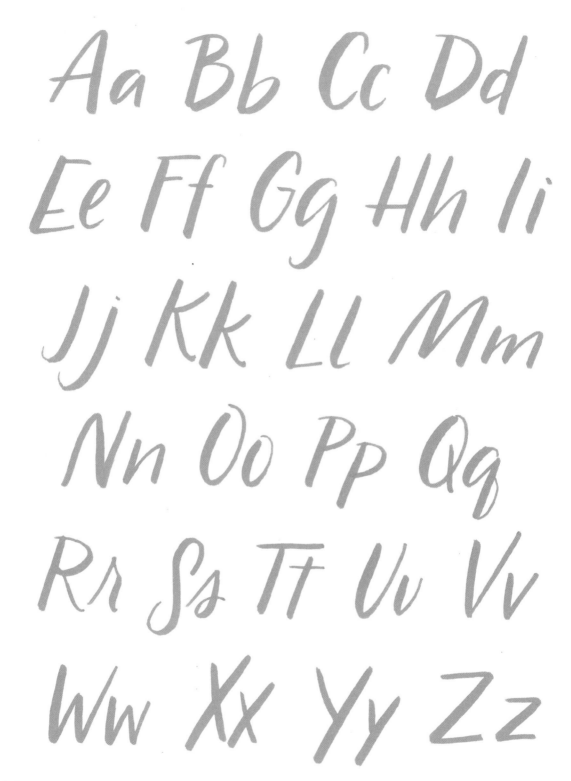

Aa Bb Cc Dd
Ee Ff Gg Hh Ii
Jj Kk Ll Mm
Nn Oo Pp Qq
Rr Ss Tt Uu Vv
Ww Xx Yy Zz

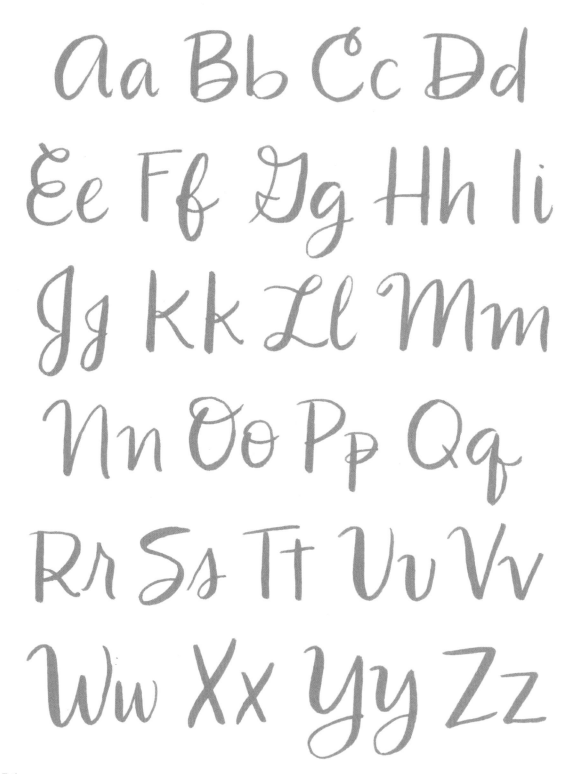

BONUS PROJECT

We're not done quite yet! Have you seen designs out in the world and thought to yourself, "Did someone letter on every single one of those?!" The answer is probably no. Here's the not-so-secret secret: they were printed. There are online sites and printmakers who can turn your design into a printed product and multiply. You can get a stamp made to add to bags, envelopes, packaging, and the list goes on. For the next party you host, you can get custom cocktail napkins printed to add some fun personality to the event. And the invite for that event can be beautifully letterpressed—a piece of paper that no one will want to put in the recycle bin. Take a look at the Resources page for some websites and talented printers. Have fun!

1) To go from your drawing to these printed products, you will need a black and white file to send to the maker. Start with drawing your designs in black on either marker paper or a very smooth paper that doesn't bleed like Bristol paper. You'll want the lettering to be a solid black so your scanner can pick up the fine lines and details.

2) Then to go from the physical sketch to the computer, the best way to do this is by scanning to at least 300 dpi (you'll see this option as a drop-down menu when you scan on your computer). However, if you don't have a scanner, there are apps that work, or even taking a photo can be an option, if needed.

3) If you're familiar with design programs, open up the file in an editing program, scale it to the size of your final product, and make it completely black. If you don't have a design program, when you are executing step 1, draw your design the exact size you'd like the final product to be, similar to what I did with the *thank you* stamp here.

4) Save your file as a JPEG or a PDF and submit it to the maker.

5) Once you receive your physical product in the mail, stamp away and add your lettering to anything and everything. Enjoy!

 One thing I'd like to note though is that you may be asked to send a vector file, which means you'll need to use a design program. There are several great online learning sites I listed in the Resources section to get a basic understanding of these programs. And Adobe, the software company responsible for them, has a free 7-day trial you can test out.

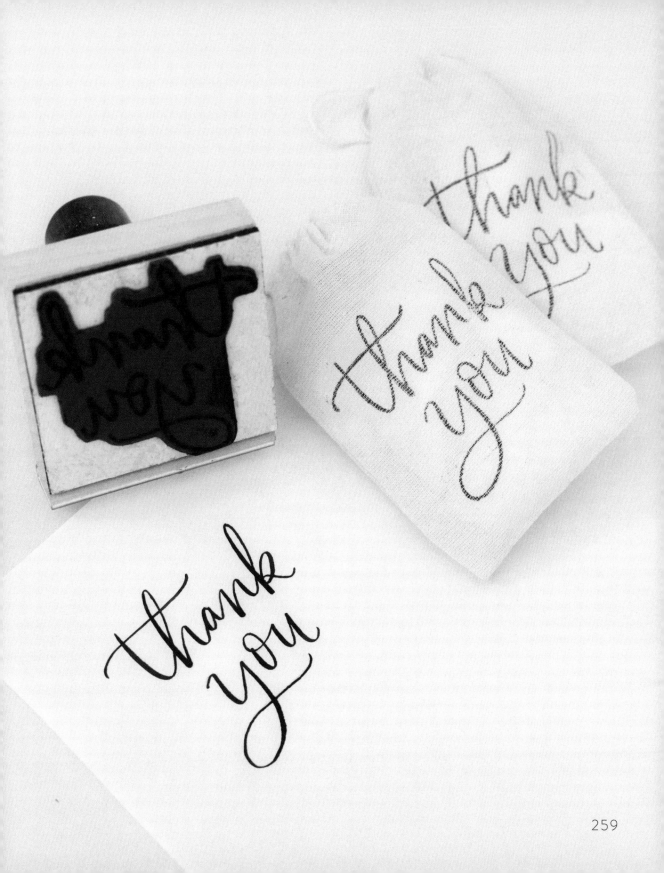

CONCLUSION

I've got one final thing for you. As our last exercise together, I'd like you to take out a piece of paper and any one of your lettering tools. Now, go back to the beginning and find the first word you lettered from this book. Write out that same word for me once more, this time using all your new skills.

Do you see a difference? I hope your answer is yes! But even more than that, I hope you feel a sense of warmth in your heart, seeing how far you've come and what you've learned. This moment doesn't signify that "you have arrived" and it doesn't mean you need to show off what you've learned to everyone you know. This is a moment *just for you*. It's an opportunity to pause and give yourself a little love and say, "Hey, I see you and all the cool things you're doing over there." This is your very own permission slip, a hand reaching out, equally daring and encouraging you to continue on this journey. But the truth is, you don't need an invite from me or anyone else; all you need is to continue to put one foot in front of the other, just like you have been.

When I first started lettering, no one gave me permission. I was not granted the degree to do this by a lettering guru, and journeying for myself was equal parts exciting and scary. For a while, I felt inadequate. It's scary to put yourself out there, to be vulnerable, to be seen and potentially critiqued. But you know what? I wouldn't be here, in this moment with you, if I hadn't

clink

give myself the permission to at least try and, ultimately, trusting and having faith that that little whisper of "hey, I see you" was something I needed to listen to.

I'm not telling you to devote your life to practice lettering every single day for hours on end, because the reality is no one has the time for that. But I bet you have pockets of time that can be used in a new way. Instead of grabbing your phone to scroll through social media, write out your favorite quote on a sticky note. At night before you go to bed, grab your brush pen and the notebook we made in lesson 7, and write one thing you're grateful for. And then the next day, when you find another ten-minute window, grab a piece of marker paper and use it to trace over the words you wrote the day before. Try one of these lessons and see what you can do to make your lettering look different. Can you change the angle, the spacing, the shape? Can you change the connection? Can you add a flourish?

Be willing to experiment. You have the *why*, and you have the *how*.

It's truly been a pleasure sharing this journey with you . . . and I know we're just getting started. I honor and respect you for having the willingness to try, to push yourself, to create something by hand, and to share a little piece of you. The next time you walk into a craft store with a friend, and she goes to buy a garland for the upcoming party, you can whisper to her, "psst, don't buy that, I will make that for us."

RESOURCES

Hey you! I didn't forget about all those additional website, stores, makers, and tools I mentioned throughout the book. Here is your list to dive in and explore to keep you going on your lettering journey. Enjoy!

Other tools

Aquash water brush

Bistro chalk marker

Copic Sketch Pen

Kuretake Brush Pens

Lettermate

Minwax Polyurethane Aerosol spray

Rhodia Writing Pad

Sharpie Oil Based Paint Marker

Slider Writer

Soapstone pencil

Strathmore Bristol Paper

Tombow Fudenosuke Hard Trip brush pen

Tombow Fudenosuke Soft Tip brush pen

Other inks

Dr. Ph Martin's Acrylic Inks

Dr. Ph Martin's Hydrus Watercolors

Ecoline Liquid Watercolors

Finetec

Golden Fluid Acrylic

Pearl Ex

Sumi ink

Winsor & Newton Calligraphy Ink

Winsor & Newton Watercolors

For supplies

Blick – www.dickblick.com

Cards & Pockets – www.cardsandpockets.com

French Paper Co – www.frenchpaper.com

JetPens – www.jetpens.com

Michaels – www.michaels.com

Paper and Ink Arts – www.paperinkarts.com

Paper Presentation – www.paperpresentation.com

Paper Source – www.papersource.com

Utrechtart – www.utrechtart.com

For projects to letter on

Amazon – www.amazon.com – anything and everything

Etsy – www.etsy.com – seaglass, agate slices, vintage stamps, and more!

Jo-Ann Fabric and Crafts – www.joann.com and local stores – linen, canvas, fabric

Hobby Lobby – www.hobbylobby.com – wood dowels and other crafts

Home Depot – www.homedepot.com and local stores – wood

Online Labels – www.onlinelabels.com – blank stickers

Paper Mart – www.papermart.com – bags, boxes, packaging

Save on crafts – www.save-on-crafts.com – event decor

Tap Plastics – www.tapplastics.com – acrylic board

For custom printing

For Your Party – www.foryourparty.com – napkins, coasters, cups

Moo – www.moo.com – business cards, postcards, stickers

Rubber Stamp Champ – www.rubberstampchamp.com – stamps

Paperleaf Press – www.thepaperleafpress.com – boutique print house

Stationery HQ – www.stationeryhq.com – printed paper goods

Zazzle – www.zazzle.com – postage, personalized gifts

Additional online learning resources

There is a hub of online workshops for pretty much anything you'd like to learn. You can continue your lettering journey, learn design programs, or pick up a new hobby. Not ready to buy the design programs quite yet? Adobe offers a 7-day free trial www.adobe.com/downloads.html.

Brit + Co – great for beginners looking to dabble in a new craft. You'll find me there!

CreativeBug – I highly recommend Yao Cheng's watercolor class.

Modern Calligraphy Summit – if you're looking to take your lettering to the next level, I highly suggest this. It's a bundle of lettering classes from artists in the field. You'll find me there too!

Skillshare – Molly Suber Thorpe and Peggy Dean are great lettering artists teaching there.

Talented lettering artists

Anne Robin – www.annerobin.com

Chasing Linen – www.chasinglinen.com

Laura Hooper Calligraphy – www.lhcalligraphy.com

Logos Calligraphy (left handed) – www.logoscalligraphy.com

Molly Jacques – www.mollyjacques.com

Monvoir – www.monvoir.com

Pieces Calligraphy – www.piecescalligraphy.com

The Postmans Knock – www.thepostmansknock.com

Other talented creatives who you might like too!

Ali Makes Things – www.alimakesthings.com

Alli K Design – www.allikdesign.com

Amy Tangerine – www.amytangerine.com

Jen B Peters – www.jenbpeters.com

Jenna Kutcher – www.jennakutcher.com

Oh, Hello Friend – www.ohhellofriend.com

Sunny Y. Kim – www.sykimphotography.com

Swell Press – www.swellpresspaper.com

THANK YOU!

To everyone who has held space for me during this process, my sincerest thank you. To my sweet editor, Shannon Connors Fabricant, who saw something in me, trusted me, and became a dear friend through this all. We did it! To Susan Van Horn, who designed this beast and ever-so-kindly worked with me. And to the rest of the Running Press team, thank you for bringing me on. Never in a million years did I envision writing a book.

To Sunny, the talent behind the photos, who brought this vision to life: You are the reason I am here at this very moment, because in 2014 you sent an email asking a girl—without any background in teaching—to teach hand lettering at the Oh, Hello Friend shop. It is so special to come full circle and have your talent within these pages.

To Danni, Britt, and Dianuh, thank you for welcoming me into your homes, and allowing Sunny and me to take over and dream. Seriously, thank you.

To my dearest friends, who are my rocks—you each know who you are. Thank you for the texts and phone calls encouraging me and lifting me up when I doubted myself. You are my favorite people to do life with.

To my yoga teachers and the nice baristas at the many coffee shops where I spent hours on end: By doing your jobs, you allowed me the space to re-center myself and write these words.

To my family, you know I will always love you all through thick and thin. Thank you for teaching me what unconditional love is.

And finally a thank you to you, the reader. To each and every student, whether you're at in-person workshops, online, or you're reading on your own: you are the reason this book exists. There's something about hand lettering that we gravitate towards, and it is a way to communicate, share, and spread love to others. Use this book as a means to continue doing just that—it's what it was made for.

INDEX

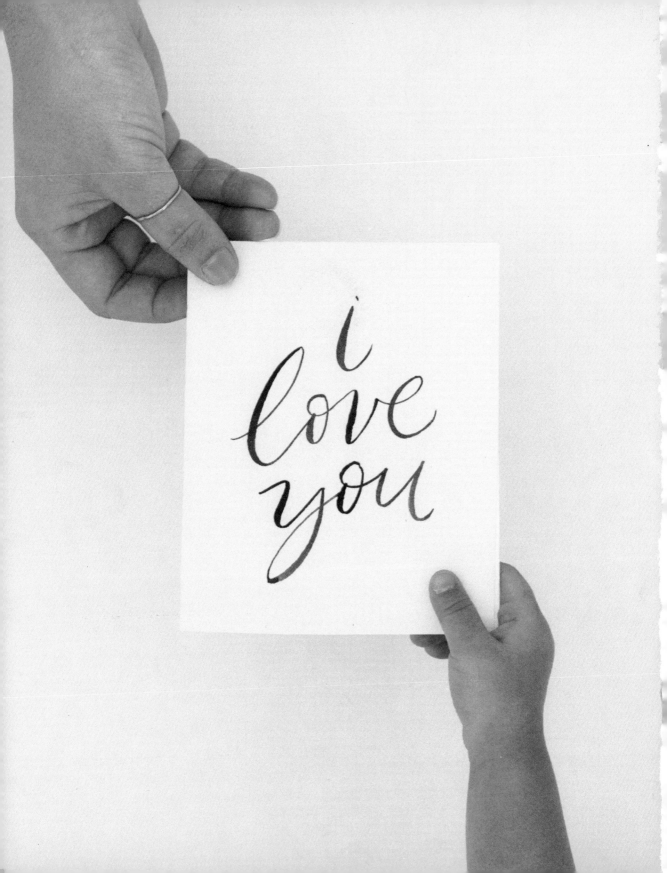